陳永浩彩墨畫集

Ink and Colour paintings of Chen Yung-Hao

新形象出版事業有限公司

陳永浩畫集

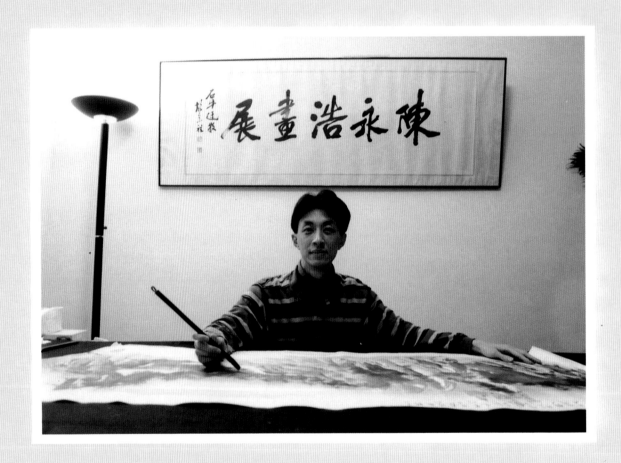

陳永浩畫集

陳君永浩天資聰穎勤奮好學
近年隨余習畫技藝精進卓犖
有成茲以佳作編印成集公諸同
好他日碩之餘期收引玉之功也
時在民主中國第八十二年歲次
癸酉暮秋石牛老叟胡念祖

惟賢惟德　能服其志

永浩道友存　癸丑年　未舒

6

君子如水刾乎涯

坡翁句瑛闍畫筆好淂卬付
永浃仁棣�态之豪牟

7

留得一腔水墨情

陳君出生於民國淳樸、風景秀麗的花蓮，幼嗜好繪畫，又自染山川大地天然造勢，產生心靈意境之磅礴，由於陳君自小對美學的執著和對色彩的敏銳，畫作的發揮，有如其個性柔化婉約和不拘小節的豪爽風格，陳君常用一句「是非是法，法非是非」的謁語，來拓展他繪畫的領域，充實他平淡的生活，酷愛山水的他，為了抓住宇宙天地間氣象萬千的變化，常常遊歷名山勝景，為了抓住生命與大自然之間的脈動，常常觀察，思維，使其畫作注入新的生命。

陳君的創作思路，題材寬廣，他的山水畫章法千變萬化，氣韻生動，構圖經營靈空凡秀，下筆氣魄，筆筆生發，且用墨大膽，由濃入淡，著色活潑柔美，所以從山水中得天地靈和之氣。他的花鳥，草蟲，每幅作品在構思及技巧上多有其獨到之處。他以奇俏的章法，充沛的激情，表現出家禽的生活意趣和特性，各類飛禽的羽片，配景合諧，相得益彰，點綴的蜜蜂，蝴蝶，螳螂，天牛，蜻蜓……等，一旦出現在他的筆下，就有暢旺的生機，另有蒼鷹，白鷺，孔雀等等，對其意境的描繪都非常得體，魚蟲與大自然的生物刻劃也都維妙維肖，栩栩欲活，似乎伸手可觸或呼之欲出，自然而然地躍然於紙上，洋溢於畫表，所以從花卉中得自然，怡和之樂，翎毛草蟲中得飛翔自得之意。且陳君大量的吸取張大千，吳昌碩，齊白石，吳冠中，胡念祖，歐豪年……等名家的筆法。做為一位傑出的畫家，陳君以其在水墨寫意畫上的成就著稱，無疑地，他多樣題材，豐富了他的藝術作品，畫出了人性的光明和大自然的溫馨。

藝術創作是一條無休止且孤獨的道路，曲折而痛苦，但他坦然面對，一點一點累積他的心性，修養，不管是否受阻，他毫無畏懼，勇敢的畫下去，一花一草一石都引他無限遐思，中國繪畫上下千載，縱橫百輩，藝苑廣如煙海，他說能否登堂入室，雖竭平生之力，亦未可知，他鍥而不舍的錚錚風骨，淡泊隨緣的人生觀，總是以誠相待。他性格倔強，在挫折面前從不氣餒，但他心地善良。冷暖人間，他認為無時無刻都是一幅完美的畫，用心傳達不同的想法，換言在繪畫時，會借這工具傳達，借法的表現，花了所有的精神經驗，智慧，包融性，所以處處為畫，處處清靜，處處蓮，欣賞畫，欣賞人生為……。

然而陳永浩是當代年青畫家之一，他曾出畫冊，都行銷一時，這次又選印了他的一些佳作，我期待這些作品的出版能證實，我對陳永浩繪畫藝術的品評是衷懇的。

A Feeling for Water and Ink

Chen Yung-Hao was born in Hualien, a pleasant city surrounded by beautiful scenery. Painting was his childhood hobby, and the mountains, rivers, and the creative power of nature produced in his soul a boundless artistic sense. With Chen's persistent grasp of aesthetics and sensitivity to color, the execution of his paintings reflects the gentleness and grace of his straightforward style. Chen often uses the phrase "Right or wrong is the way; the way is not right or wrong" to broaden the scope of his painting and enrich his life. Especially fond of landscape painting, Chen frequently travels to the mountains and other scenic spots to study the constantly shifting weather patterns, and often engages in observation and deep thinking to connect himself with the pulse of life and nature; thus pouring new life into his work.

The thems of Chen's thoughts while he creates are extensive, his landscape painting methods are ever-changing and alive with feeling, and his composition is stately and graceful. Chen executes his work with vigor, each brushstroke replete with life. He is bold in his use of ink, using varying degrees of contrast, and his application of color is vivid and elegant. In this way, he is able to capture the spirit of nature in his landscape paintings. Each of Chen's Flower & Bird and Grass & Insect paintings demonstrates his unique style both in composition and method. Using his intriguing techniques and plentiful emotion, he displays the distinctive characteristics of domestic fowl and the feathers of numerous kinds of wild birds, all in harmony with their accompanying subjects. The bees, butterflies, mantises, beetles, and dragonflies which embellish his paintings overflow with vitality, and his eagles, egrets, peacocks, and so forth appear convincingly real. His methods for painting fish, insects, and other creatures of the Earth allow the subjects to look remarkably lifelike, as if it were possible to touch them or call them out. Arranged in a natural manner, his flowers, plants, birds, and insects permeate the paper in such a way that we can derive joy and happiness from them.

Chen has been greatly influenced by the techniques of renowned artists such as Chang Ta-Chien, Wu Chang-Shuo, Chi Pai -Shih, Wu Kuan- Chung, Hu Nien-Tsu, and Ou Hao-Nien. An outstanding artist, Chen is known for his accomplishments in impressionistic Water & Ink painting. Undoubtedlty, his variety of subjects enriches his work, conveying the brightness of humanity and the warmth of nature.

Artistic creation is an endless, solitary, winding and gruelling road; but Chen faces it squarely, gradually accumulating feelding and experience. No matter what obstacles he encounters, he fearlessly continues along that road. Every flower, stone, and blade of grass sets his thoughts in motion. The history of Chinese painting spans thousands of years, and the range of its forms is like a vast ocean. Chen says that though he will expend a lifetime of effort, he does not know whether or not he will be able to master this artform completely. He is a man of steadfast moral character: his idea of life is not to bother with pettiness but to follow his dream, and he always treats others with sincerity. He has an unyielding personality, never giving up in the face of failure, but at the same time he is kind-hearted. Chen feels that the world itself, with its contrasts, forms a beautiful painting, and with care one can convey its different ideas. In other words, when painting, it is possible to express and display such ideas by using the proper tools and techniques, and applying all of one's experience, wisdom, and integrity. Thus, every place is a painting, every place is tranquil, everywhere there are lotuses; to appreciate painting and human life is indescribable.

Though Chen Yung-Hao is one of many contemporary young artists, his first book sold out very quickly. Now he has chosen to release his second book: a collection of his best works. I expect that the publication of this collection will verify that my comments about his works is sincere.

Chen Wei-Hsien
Art Critic

目錄 Contents

春風得意冠群芳
peony
Ink and color on paper. 16

朝發
starting on a Journey in the Morning
Ink and color on paper. 17

家住雲深處
Hermitage in cloudy Mountains
Ink and color on paper. 18

秋山暮靄
Autumn Mountains at Dusk
Ink and color on paper. 19

彩舞
Dancing Colours
Ink and color on paper. 20

雄鳴
Dawn Herald
Ink and color on paper. 21

憩鹿
Deer
Ink and color on paper. 22

膏火
Midnight
Ink and color on paper. 23

花明鳥媚
Vins
Ink and color on paper. 24

山蒼白雲
Mountains and clouds
Ink and color on paper. 26

荷
Lotus
Ink and color on paper.

雪兆年豐
Snowy Scene
Ink and color on paper. 27

荷花
Lotus
Ink and color on paper. 28

冬
Winter
Ind and color on paper.

翠谷尋幽
secluded Mountains and Green Valley
Ink and color on paper. 29

海鷹
Eagles by the Sea
Ink and color on paper. 30

關山行旅
Travelling In the Mountain
Ink and color on paper. 31

山居圖
Mountain Habitat
Ink and color on paper. 32

故鄉
Hometown
Ink and color on paper. 33

溫泉之鄉
Land of Warm spring
Ind and color on paper.

泉
Water
Ink and color on paper. 34

玫瑰
Rose
Ink and color on paper. 36

大富貴
Peony
Ink and color on paper. 38

富貴繁華
Peonies
Ink and color on paper. 40

秋溪飛瀑
Autumn Waterfall
Ink and color on paper. 41

村居晴晚
Village at Dusk
Ink and color on paper. 42

海之夢
Dream of the sea
Ink and color on paper. 43

雄獅
Lion
Ink and color on paper. 44

秋山曉色
Twilight In Autnmn Mountains
Ink and color on paper. 46

臥
Reclining
Ink and color on paper. 47

松鄉
Pine forst
Ink and color on paper. 48

幽崖古瀑
Mountain Cliffs and Waterfall
Ink and color on paper. 50

馳風
Galloping
Ink and color on paper. 51

干重山
Mountain After Mountain
Ink and color on paper. 52

雲壑幽居
Desolate Hermitage in Mountains
Ind and color on paper. 54

富貴來考
Peony and Ruok
Ind and color on paper. 56

盹
Napping
Ind and color on paper. 57

亂石崩雲
Rocks and Billow
Ink and color on paper. 58

木棉
Blossoms
Ink and color on paper. 60

數峰出雲間
Clondy Mountains
Ink and color on paper.

Peony
Ink and color on paper 61

固一身之清也
The fallen kapok
Ink and color on paper. 62

人間第一香
Peony
Ink and color on paper. 63

寒山踏雪
Snow Trarelling in Wintry Monntains
Ink and color on paper.

瀑影
Waterfall
Ink and color on paper. 64

寒山子題壁
Han shan.a chan Puet of hte tang Dynasty
Ink and color on paper. 66

濶浦遙山
Land And River Seen Afar
Ink and color on paper. 67

溪山清夏
summer Monntains
Ink and color on paper. 68

根香
Vegetables
Ink and color on paper. 70

秋浦歸舟
Returning sail
Ink and color on paper. 71

秋溪暮色
Autumn Scenery at Nightfall
Ind and color on paper. 72

石
Stone
Ind and color on paper.................... 73

湖畔
Lakeside scene
Ind and color on paper. 74

重泉
Flush After Rain
Ink and color on paper. 76

牡丹
Peony
Ink and color on paper. 77

荷
Lotus
Ink and color on paper. 78

空谷流泉
Desolate Valley and Flowing Streams
Ind and color on paper. ..80

秋溪曉渡
Crossing a Creek at Dawn in Autumn
Ind and color on paper. .. 81

春
Spring
Ind and color on paper.

夏
Summer
Ind and color on paper................... 82

鸚鵡
Parrot
Ind and color on paper.

臨風
Ode to the wind
Ind and color on paper. 83

春江躍鯉
Fish
Ind and color on paper................... 84

秋
Autumn
Ink and color on paper................... 86

猿憩
Monkey
Ink and color on paper................... 87

高岩古堡
Old Monastery In the Hills
Ink and color on paper. 88

富貴白頭
Peony 90
Ink and color on paper................

荷花
Lotus
Ink and color on paper................... 91

虎
Tiger
Ink and color on paper. **92**
雞
Rooster
Ink and color on paper. **93**
木棉紅占嶺南春
Kapok Aflame
Ink and color on paper. **94**
新秋暮色
Autumn Scenery at Dusk
Ink and color on paper. **96**
蟹
Crab
Ink and color on paper. **97**
春山疊翠
green Monntains in Spring
Ind and color on paper. **98**
紫氣
A clond of Purple
Ind and color on paper. **99**
花
Flowers own
Ink and color on paper. **100**
雞
Dawn Herald
Ink and color on paper.
只要我長大
If Only I Grow up
Ink and color on paper. **102**
松鶴延年
Pine and Crane
Ink and color on paper. **103**
溪山疊嶂
Mounfains and streams
Ind and color on paper. **104**
柳蔭浴牛
Buffalo Bathing Under the willow
Ink and color on paper. **106**
鍾馗倚醉
Intoxicated chung Kuei—a Demon slayer
Ink and color on paper.**107**
山居暮色
Mountain Habitat at Dusk
Ink and color on paper. **108**
泉潤飛鳴
Waterfall
Ind and color on paper. **110**
湖山清夏
summer Landscape
Ind and color on paper. **112**

清聲
Chirping
Ind and color on paper. **113**
野草
Wild Grass
Ink and color on paper. **114**
天光雲影
Sunshine and clouds
Ink and color on paper. **115**
虎步
Tiger
Ind and color on paper. **116**
日落大地
sunset
Ind and color on paper. **118**
白雲故鄉
My Native Land Under White Clonds
Ind and color on paper.
鶴舞
Cranes
Ind and color on paper. **120**
竹
Bamboo
Ind and color on paper. **121**
園林
conntryside
Ind and color on paper. **122**
雲山縹渺
The Munntains and clonds in a dim View
Ind and color on paper.
歸舟
R eturning boat
Ind and color on paper. **123**
春深霸衆香
spring splendor
Ink and color on paper. **124**
歲寒不受雪霜侵
Bird and Tea Blossons
Ink and color on paper. **126**
雲山暮靄
Landscape at Evening
Ind and color on paper.
幽泉
Waterfall
Ink and color on paper. **128**
春容
Spring Glow
Ink and color on paper. **130**
晚霞撒錦
Evening clonds Look Like Brocade
Ink and color on paper. **132**

花香蝶己知
Peony and butterfly
Ink and color on paper.133
春林對坐
Sitting Under The spring Tree
Ink and color on paper.　..................134
白雲出岫
Mountains and white Clouds
Ink and color on paper.
湖畔春晴
Ladeside Scene in spring
Ink and color on paper.136
寧靜
silence
Ind and color on paper138
仙源何處尋
Where the Fairyland Conld Be Fonnd
Ind and color on paper.　..........139
先知
Fortune－Teller
Ink and color on paper.140
秋瓜
Pumpkin
Ink and color on paper.141
獨立
Morning Watch
Ink and color on paper.
孔雀
Peacock
Ink and color on paper.142
坡
slope
Ink and Color onpaper143

陳永浩彩墨畫

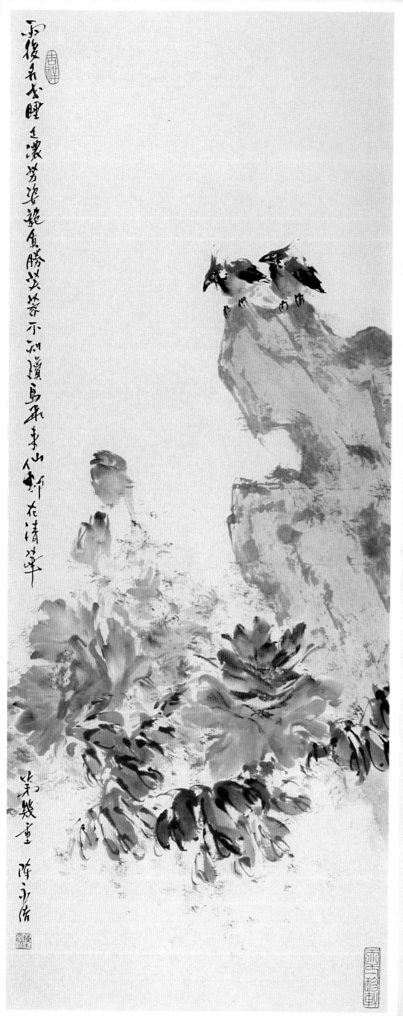

春風得意冠群芳
peony
Ink and color on paper.

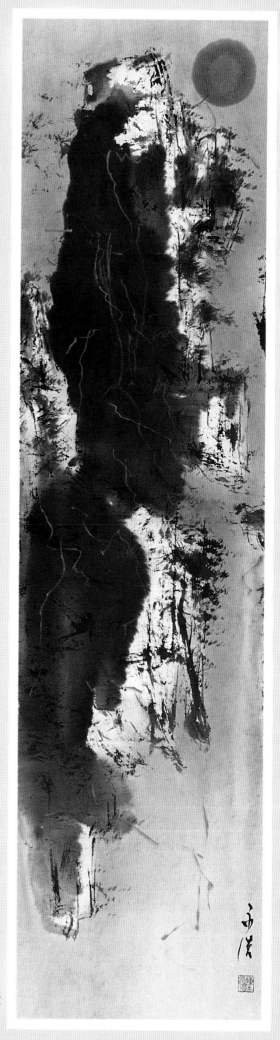

朝發

starting on a Journey in the Morning

Ink and color on paper.

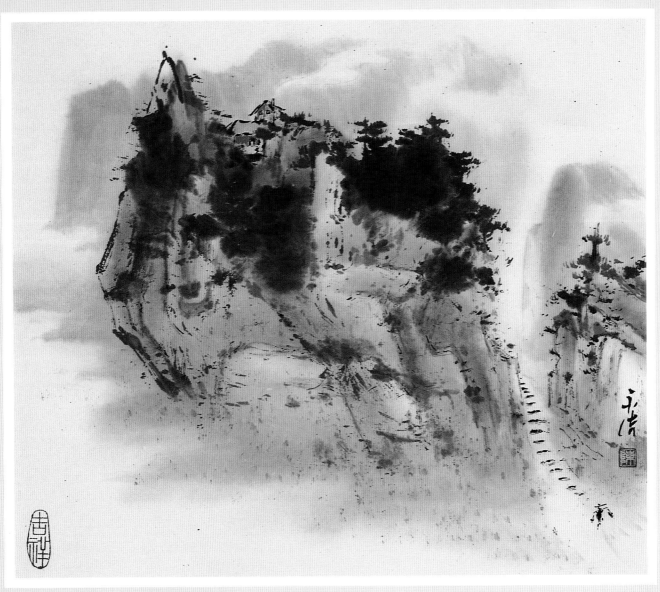

家住雲深處
Hermitage in cloudy Mountains
Ink and color on paper.

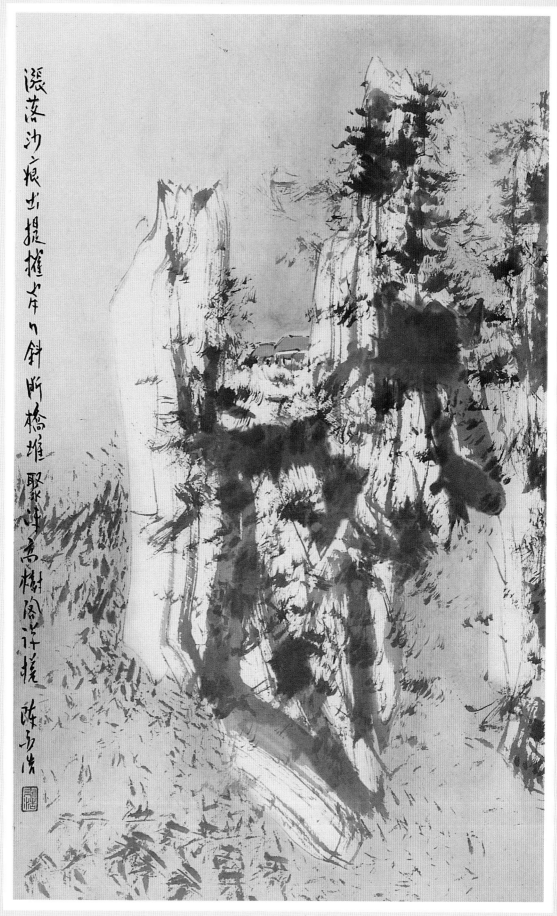

秋山暮靄
Autumn Mountains at Dusk
Ink and color on paper.

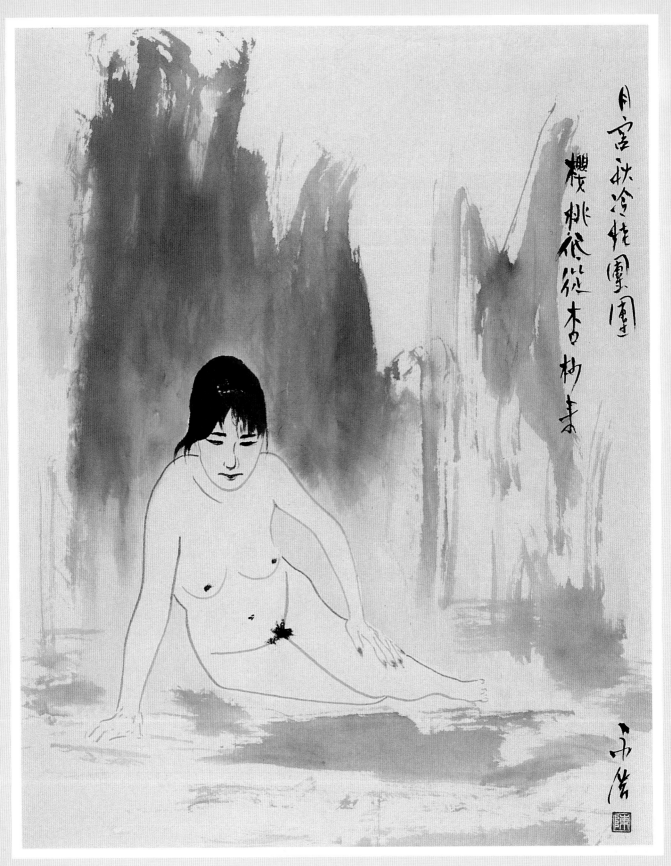

月宮秋冷桂團圍
櫻桃低從杏�來

彩舞
Dancing Colours
Ink and color on paper.

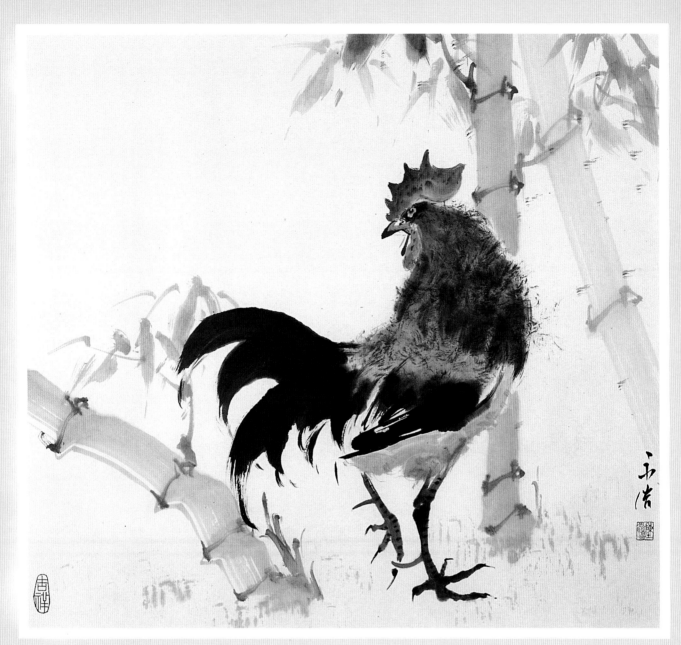

雄鳴

Dawn Herald

Ink and color on paper.

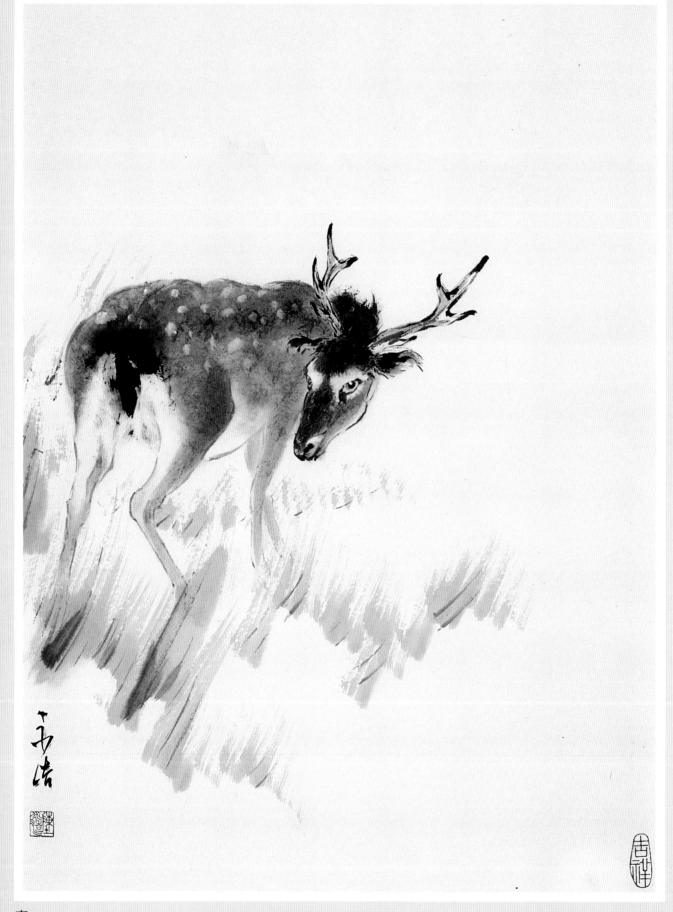

鹿
Deer
Ink and color on paper.

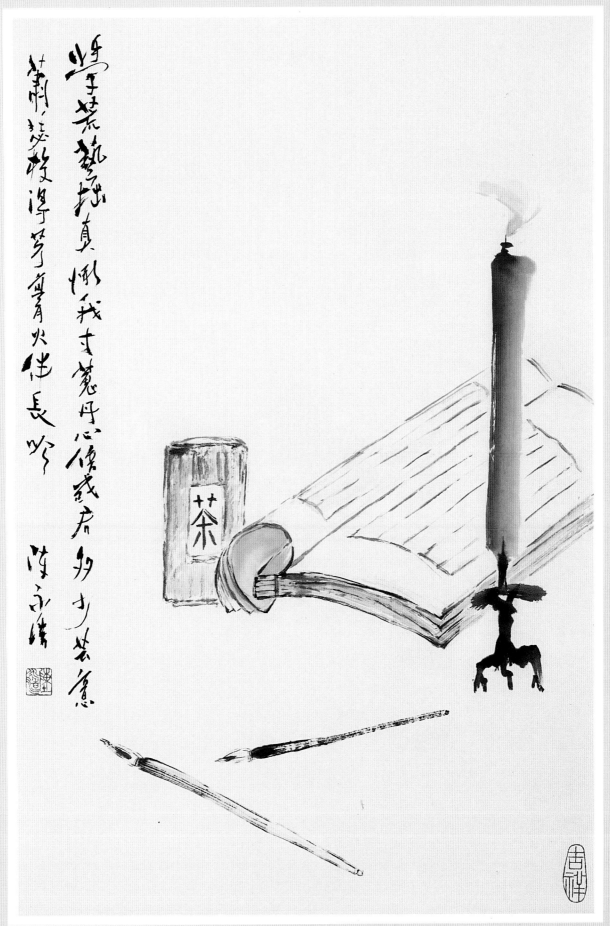

膏火

Midnight

Ink and color on paper.

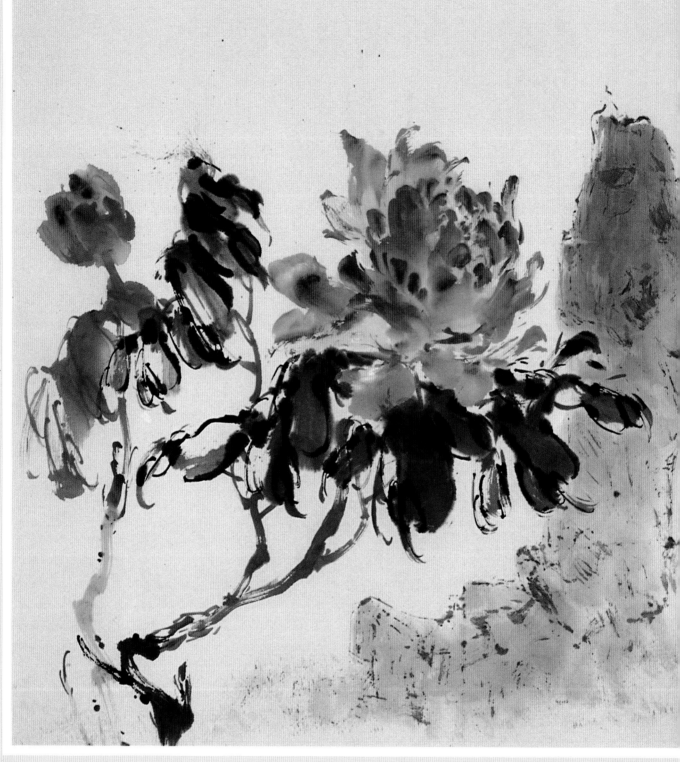

花明鳥媚
Vins
Ink and color on paper.

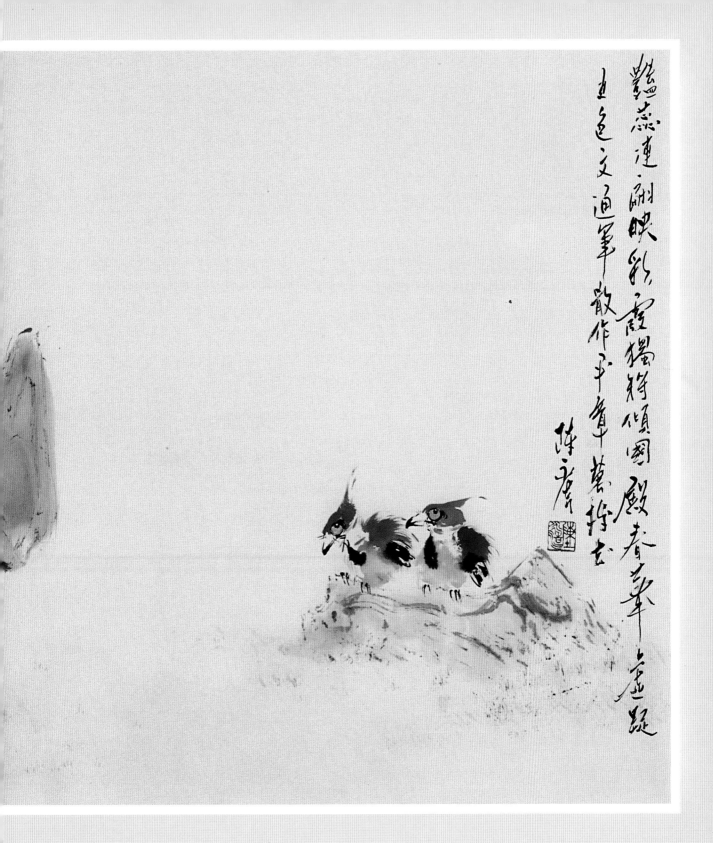

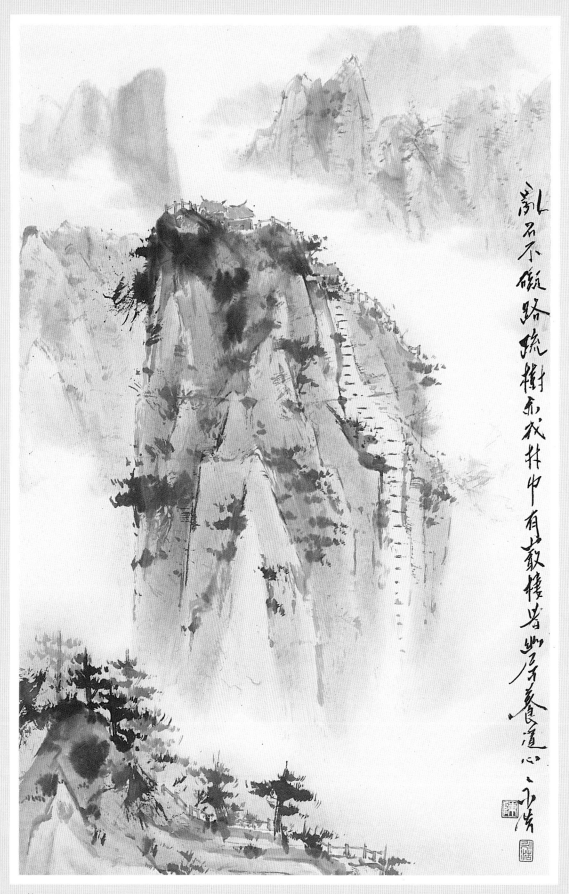

山蒼白雲

Mountains and clouds

Ink and color on paper.

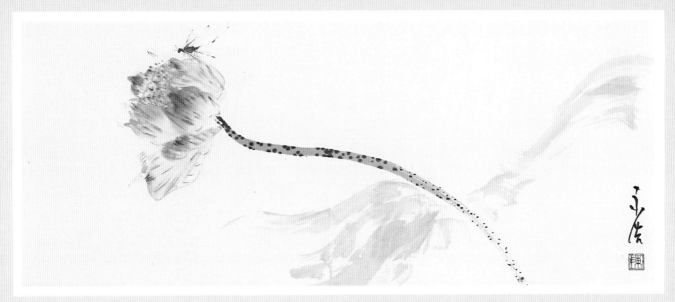

荷
Lotus
Ink and color on paper.

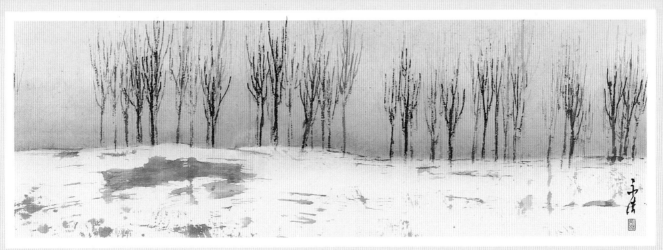

雪兆年豐
Snowy Scene
Ink and color on paper.

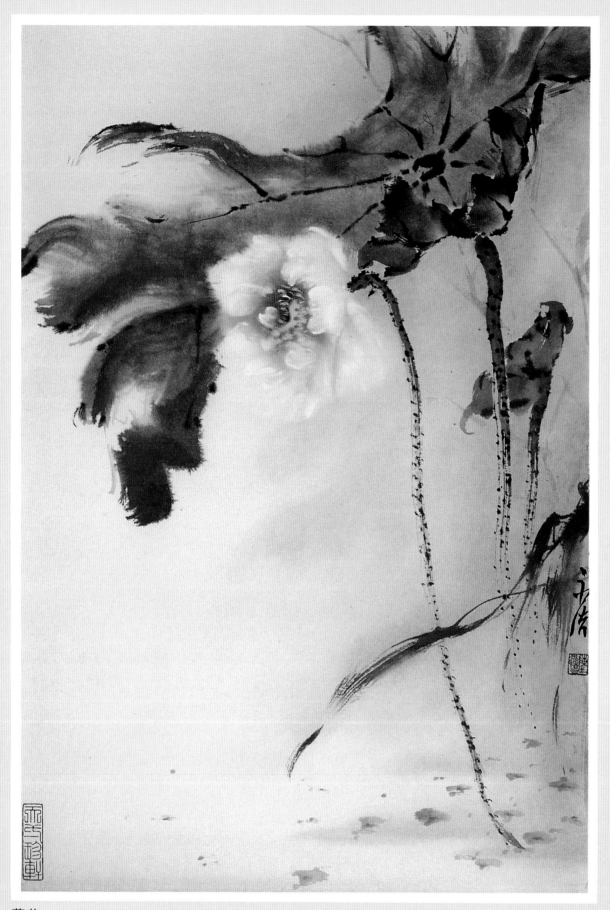

荷花
Lotus
Ink and color on paper.

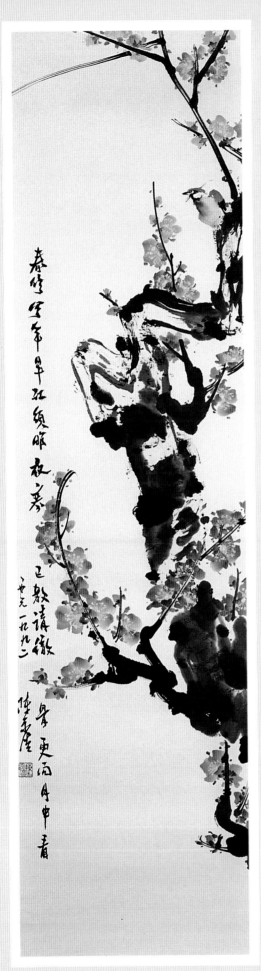

冬
Winter
Ind and color on paper.

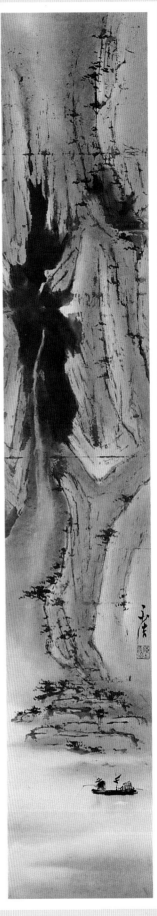

翠谷尋幽
secluded Mountains and
Green Valley
Ink and color on paper.

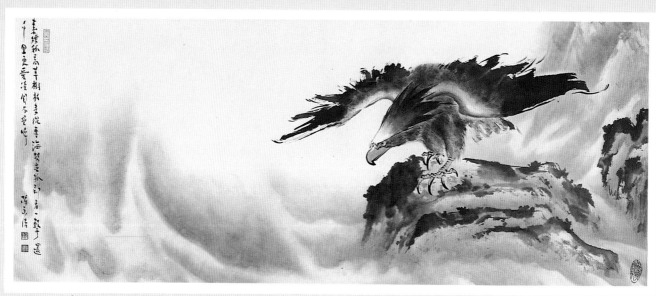

海鷹

Eagles by the Sea

Ink and color on paper.

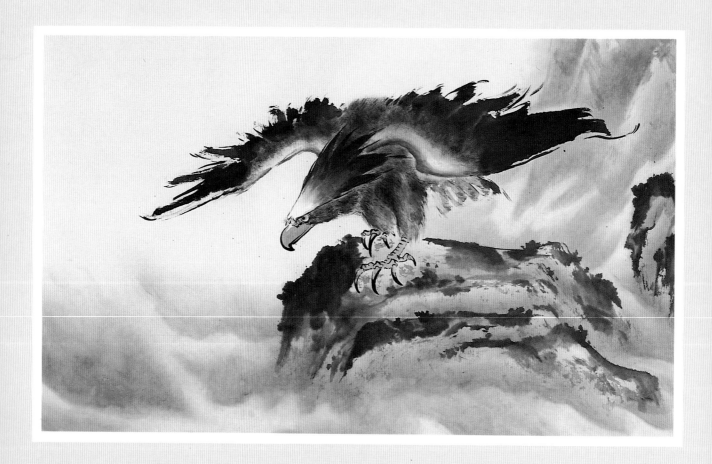

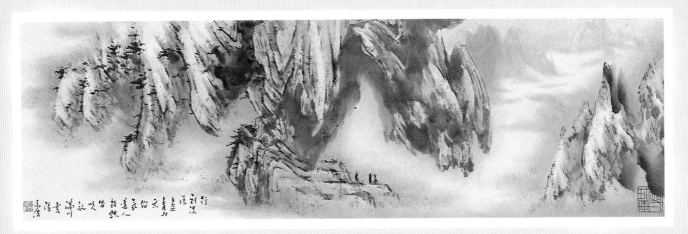

關山行旅

Travelling In the Mountain

Ink and color on paper.

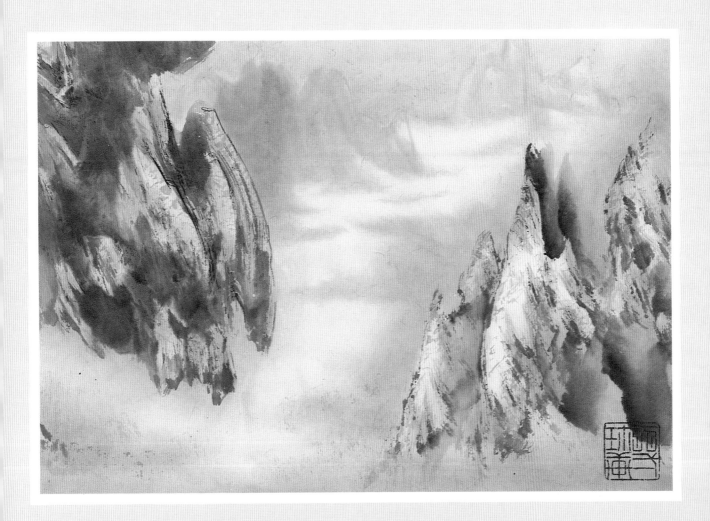

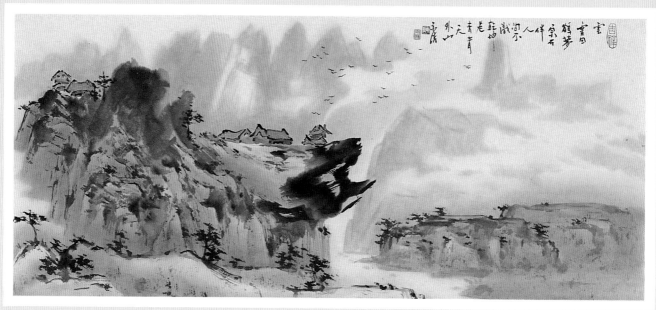

山居圖
Mountain Habitat
Ink and color on paper.

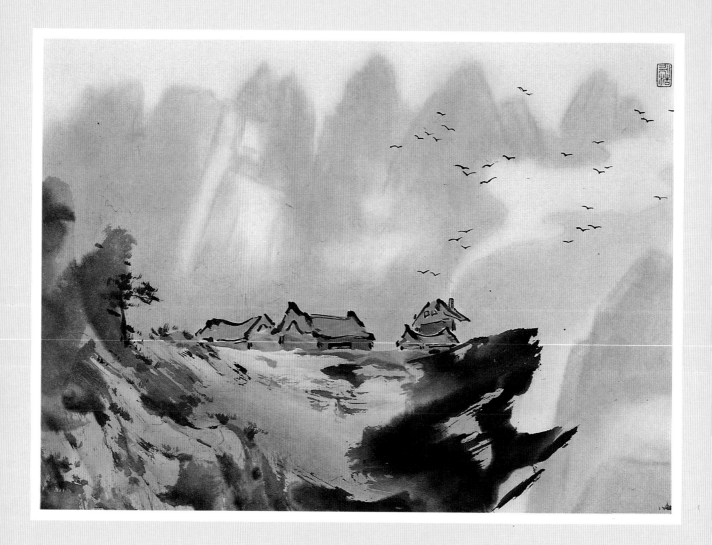

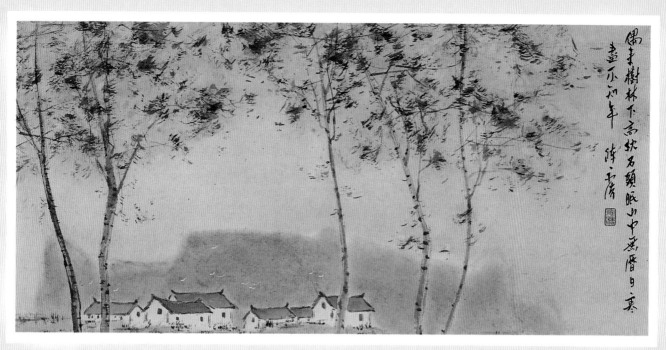

故鄉
Hometown
Ink and color on paper.

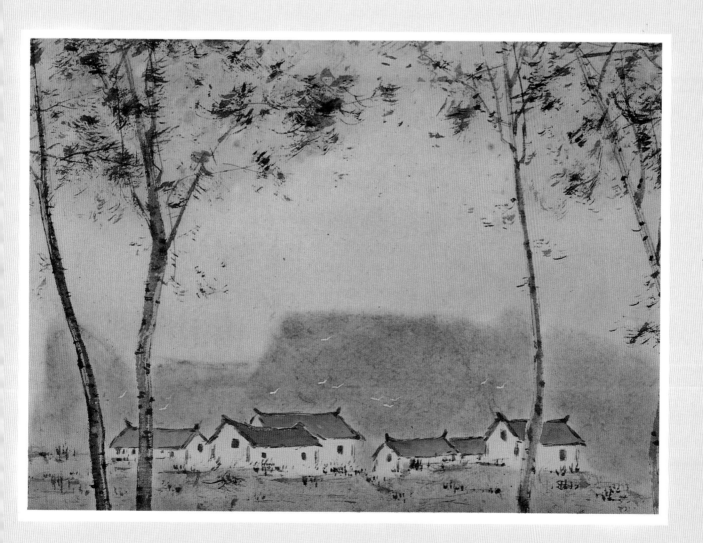

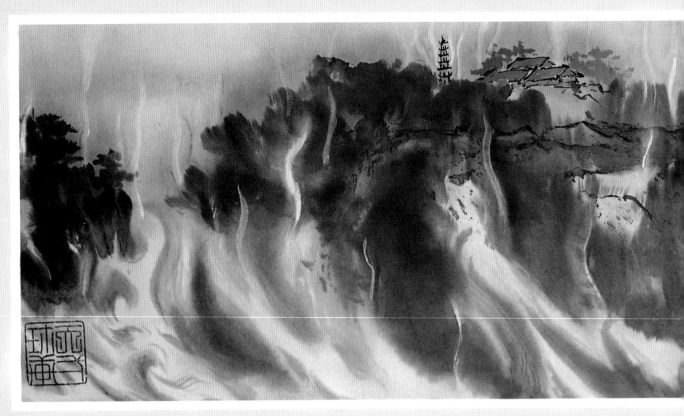

溫泉之鄉
Land of Warm spring
Ind and color on paper.

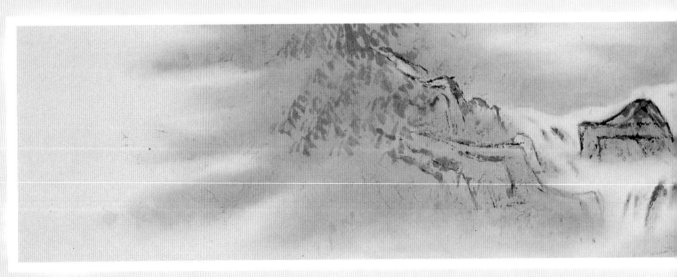

泉
Water
Ink and color on paper.

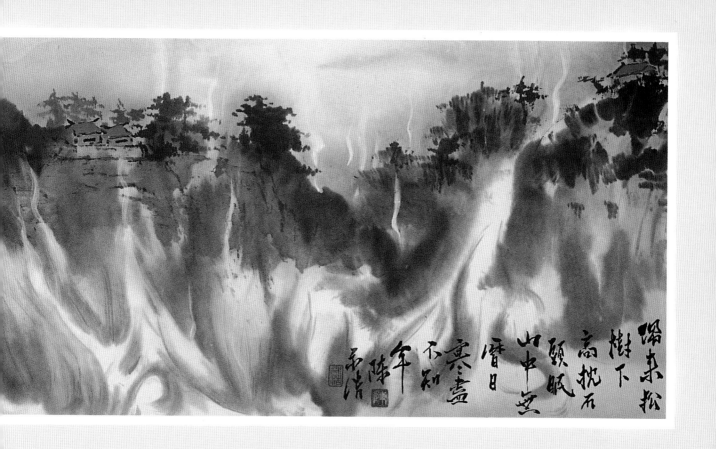

偶來松樹下
高枕石頭眠
山中無曆日
寒盡不知年
陳清泉

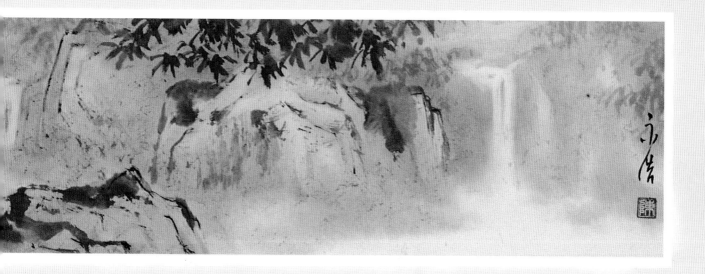

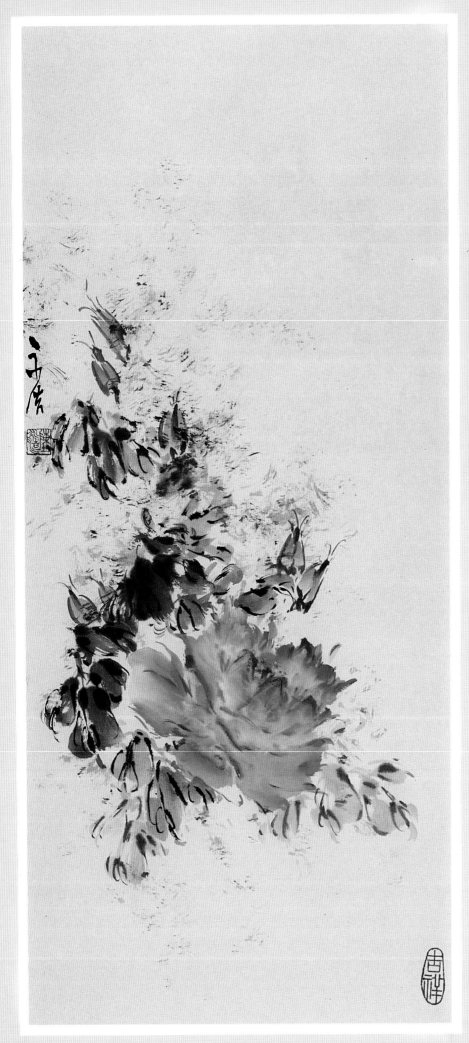

玫瑰
Rose
Ink and color on paper.

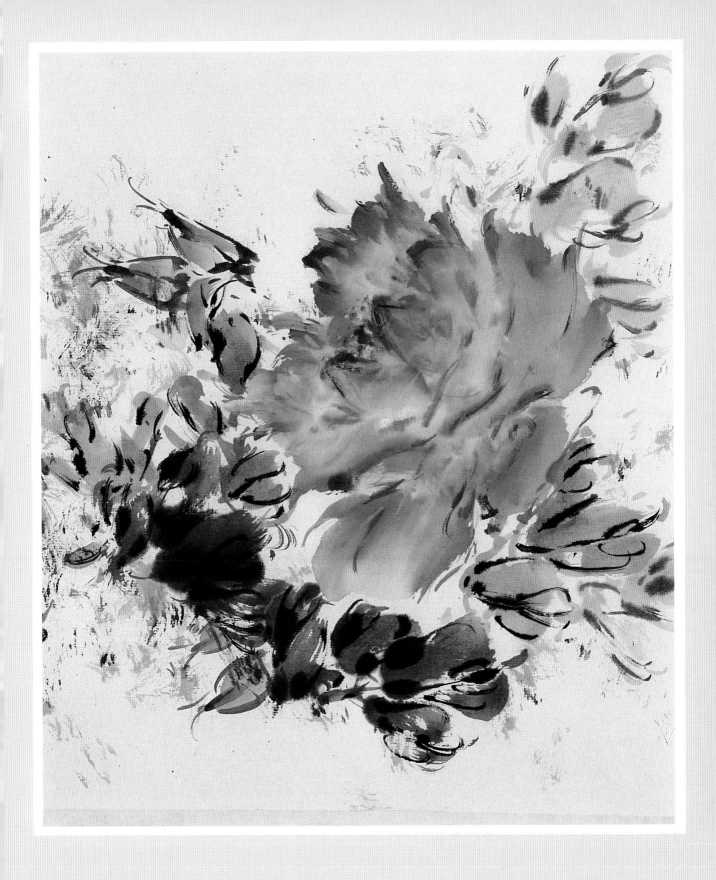

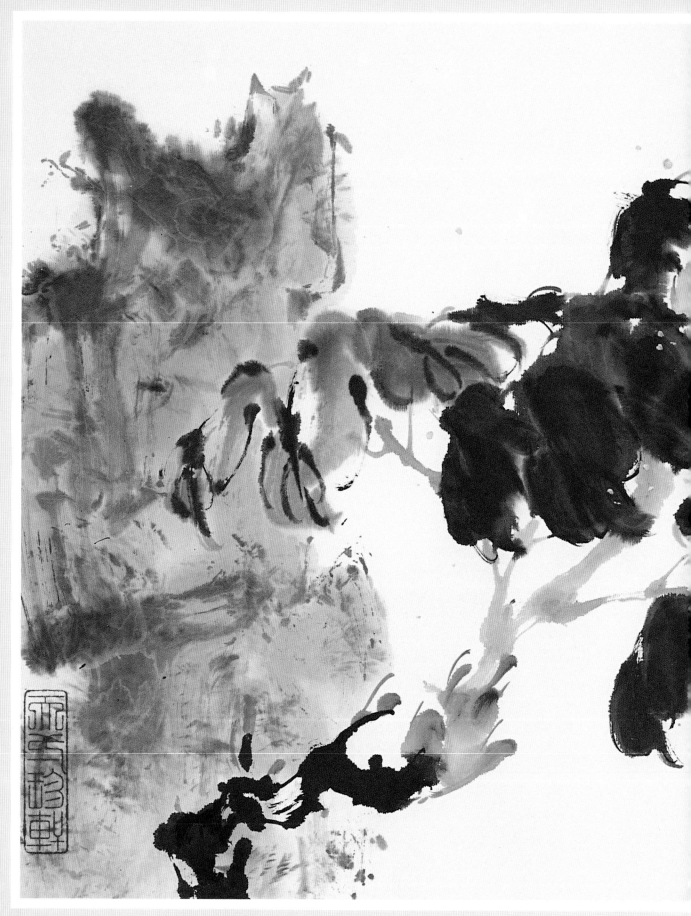

大富貴

Peony

Ink and color on paper.

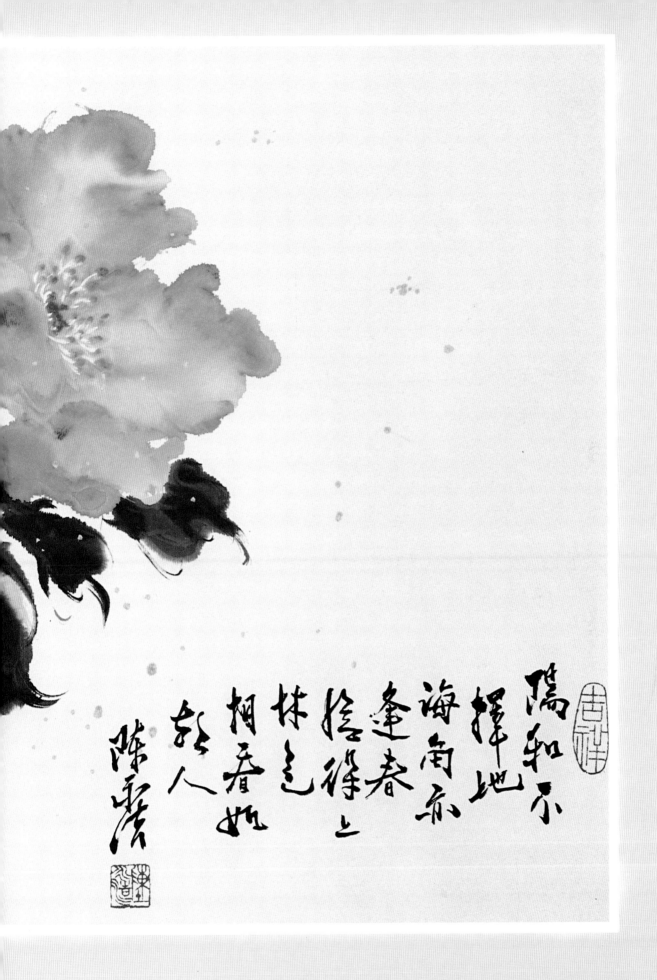

隔和不擇地
海角逢春
拾得上
林花
相看如
故人

陳澄

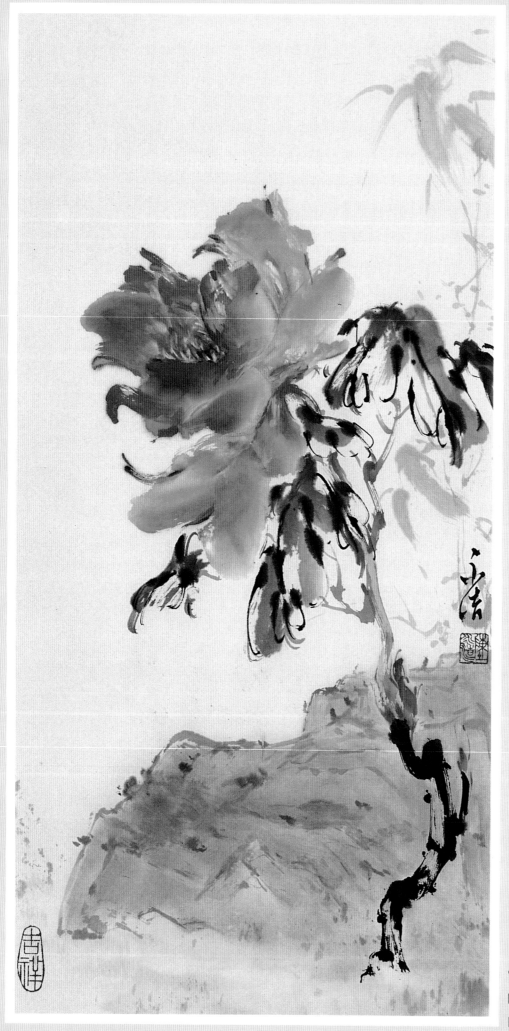

富貴繁華
Peonies
Ink and color on paper.

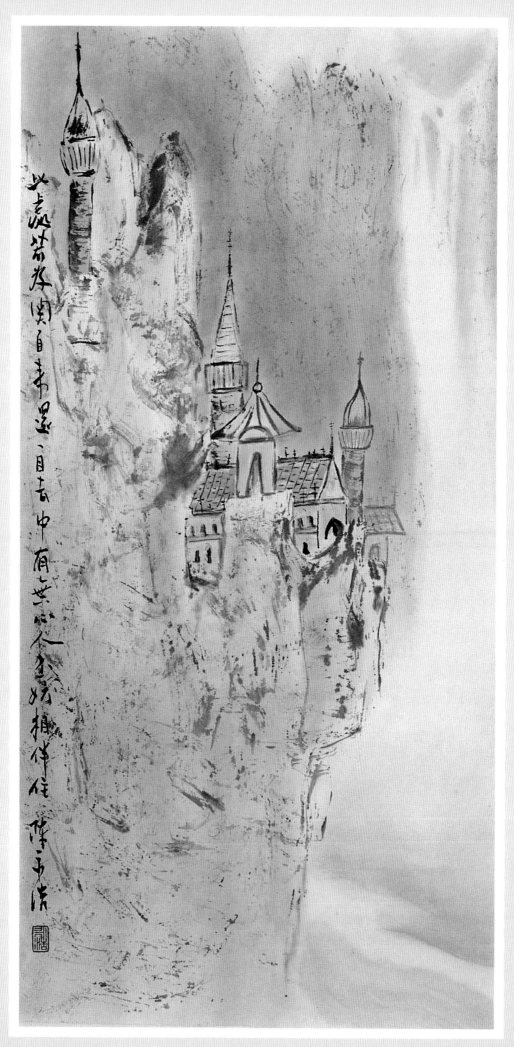

秋溪飛瀑

Autumn Waterfall

Ink and color on paper.

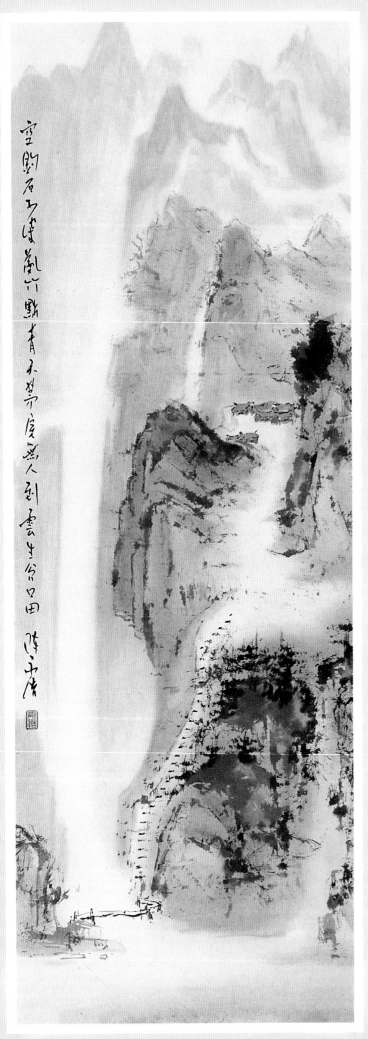

空山石上煙亂六點青不
掃虛庭無人到雲生谷口田
陳丹誠

村居晴晚
Village at Dusk
Ink and color on paper.

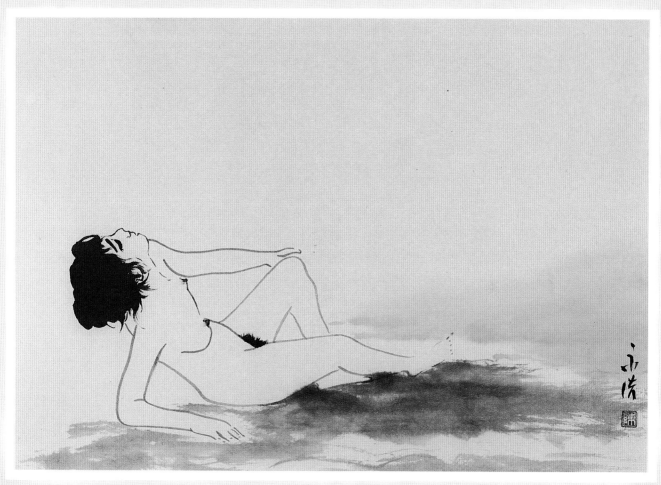

海之夢
Dream of the sea
Ink and color on paper.

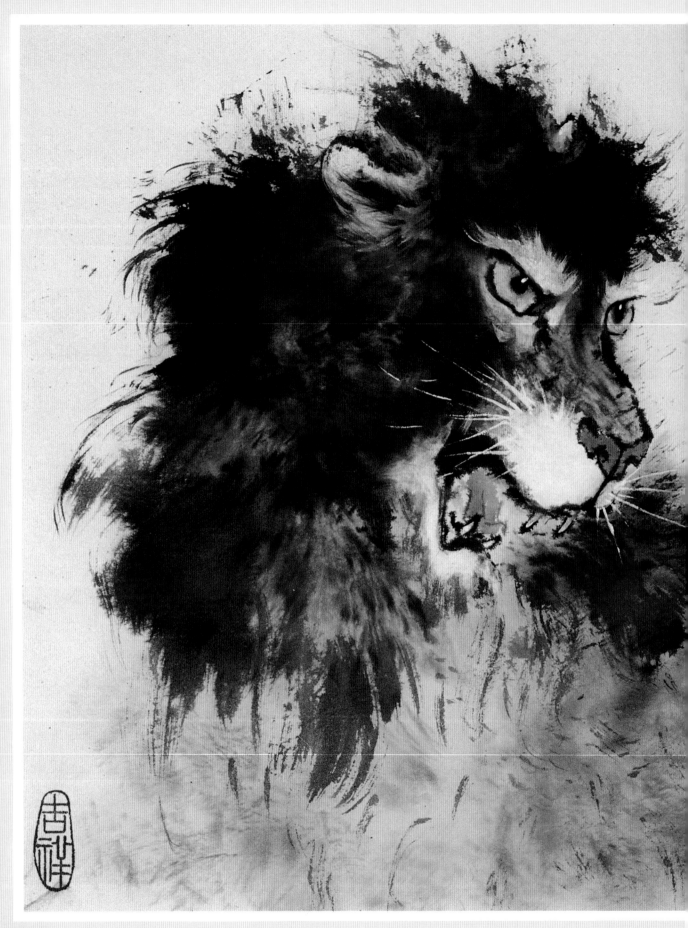

雄獅
Lion
Ink and color on paper.

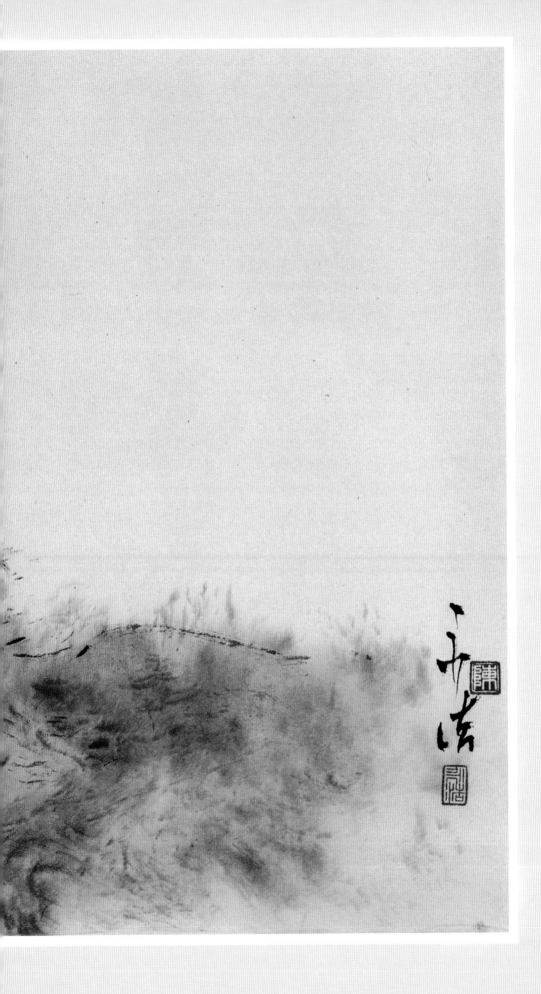

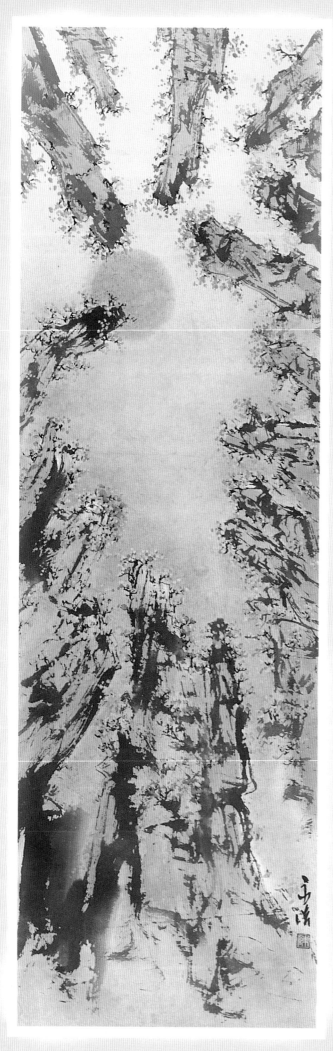

秋山曉色
Twilight In Autnmn Mountains
Ink and color on paper.

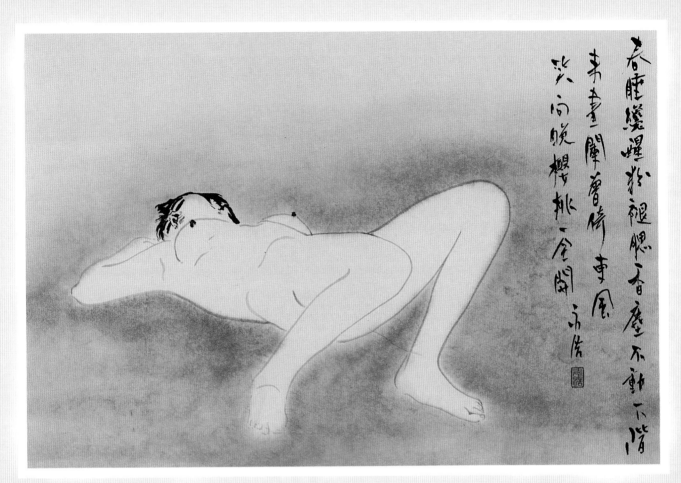

春睡變醒於褪腮香塵不動衣階
未畫闌眉倚束風
笑向脫櫻桃一含開 永偕

臥
Reclining
Ink and color on paper.

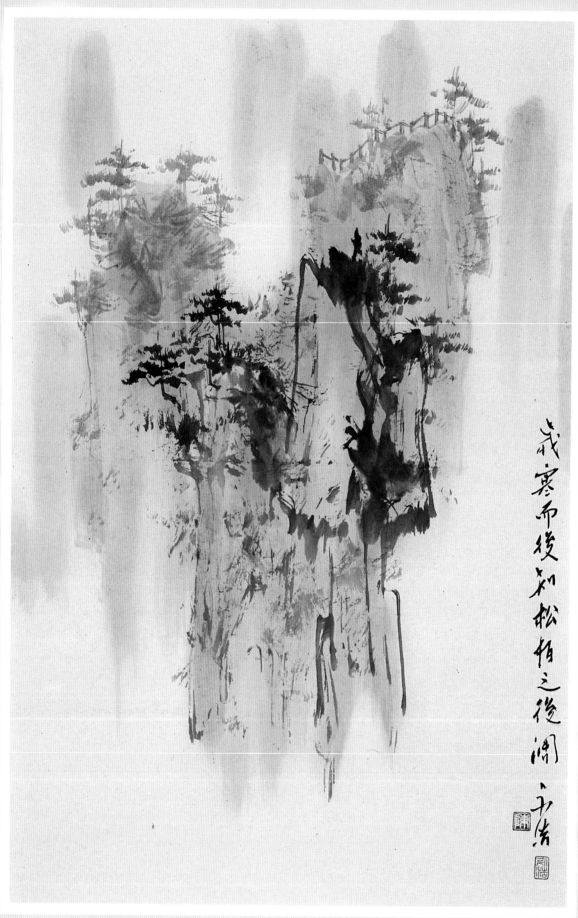

松鄉

Pine forst

Ink and color on paper.

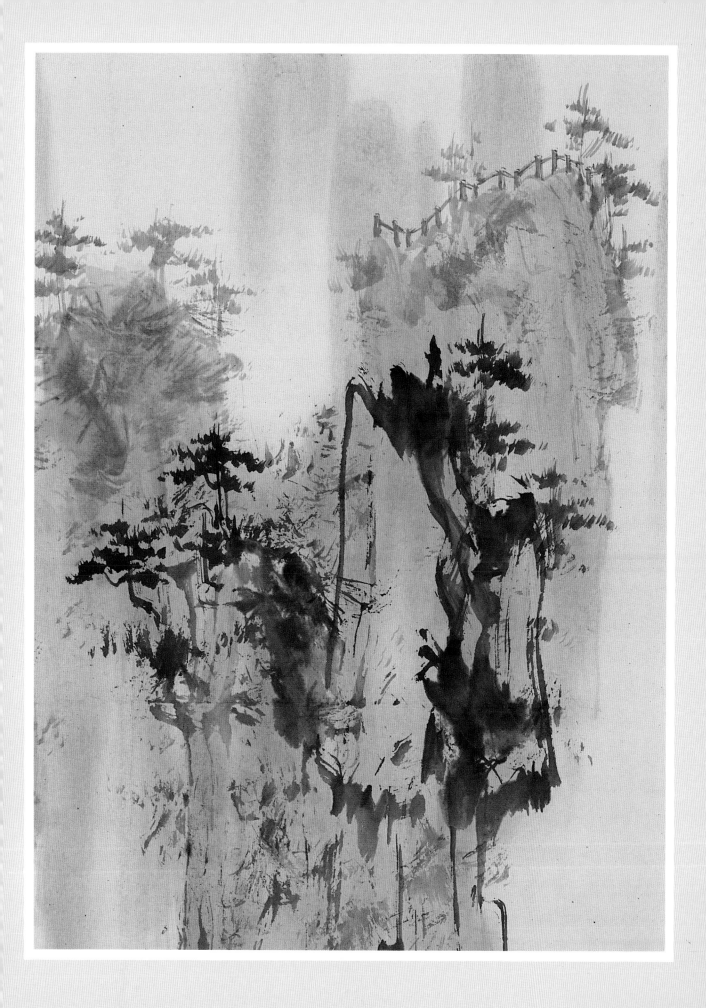

49

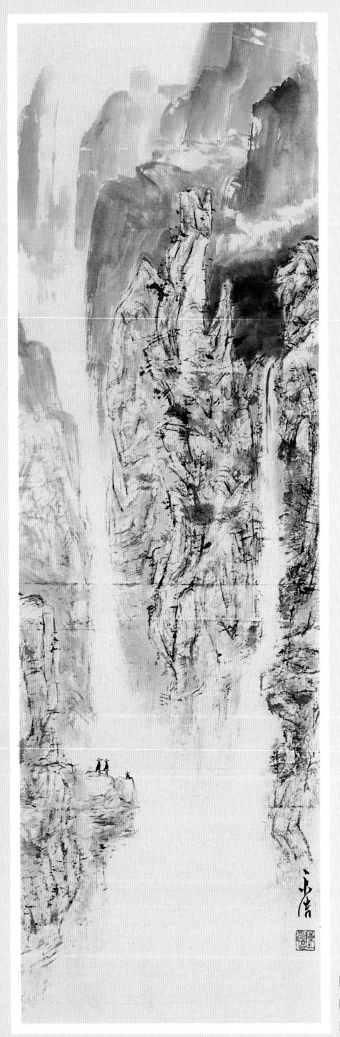
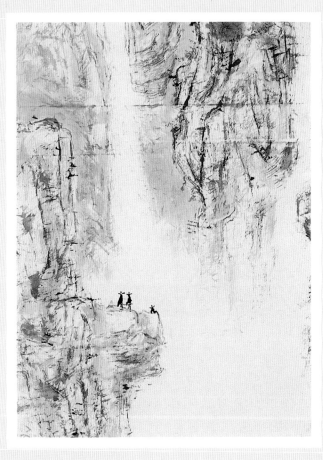

幽崖古瀑
Mountain Cliffs and Waterfall
Ink and color on paper.

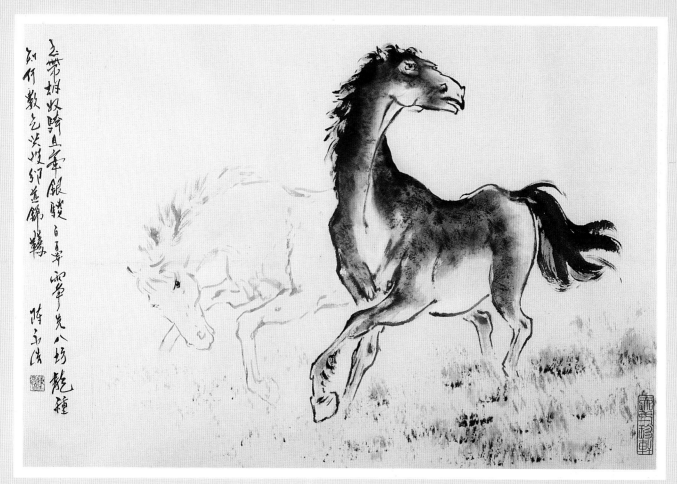

馳風

Galloping

Ink and color on paper.

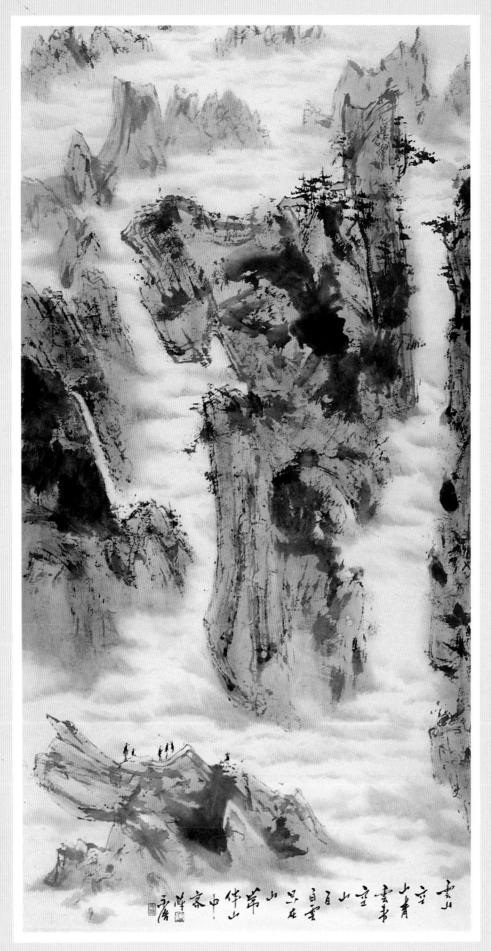

干重山

Mountain After Mountain

Ink and color on paper.

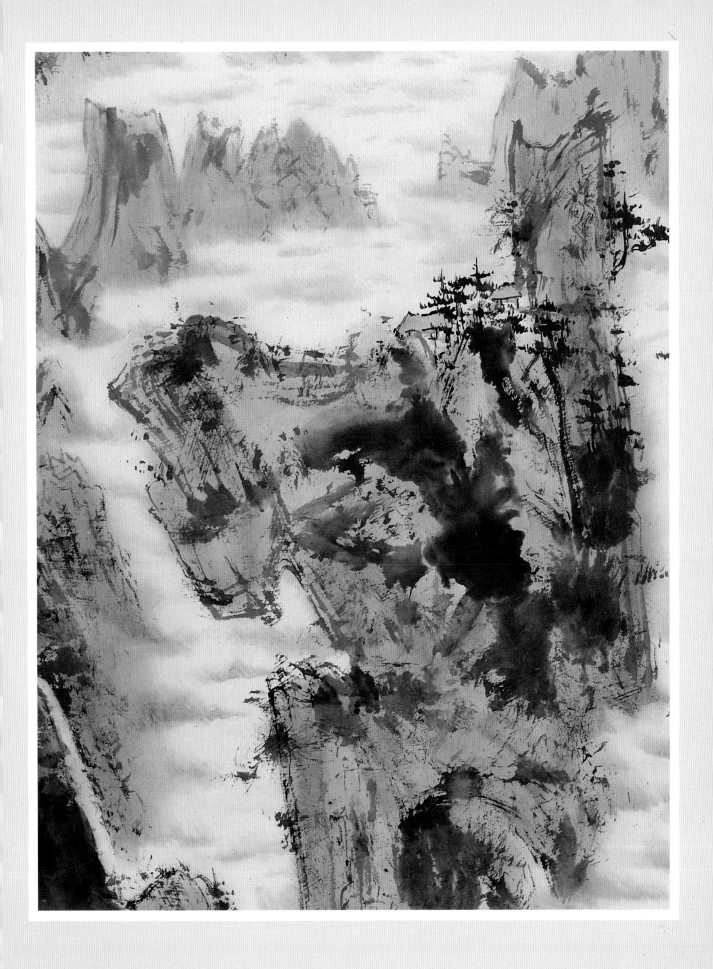

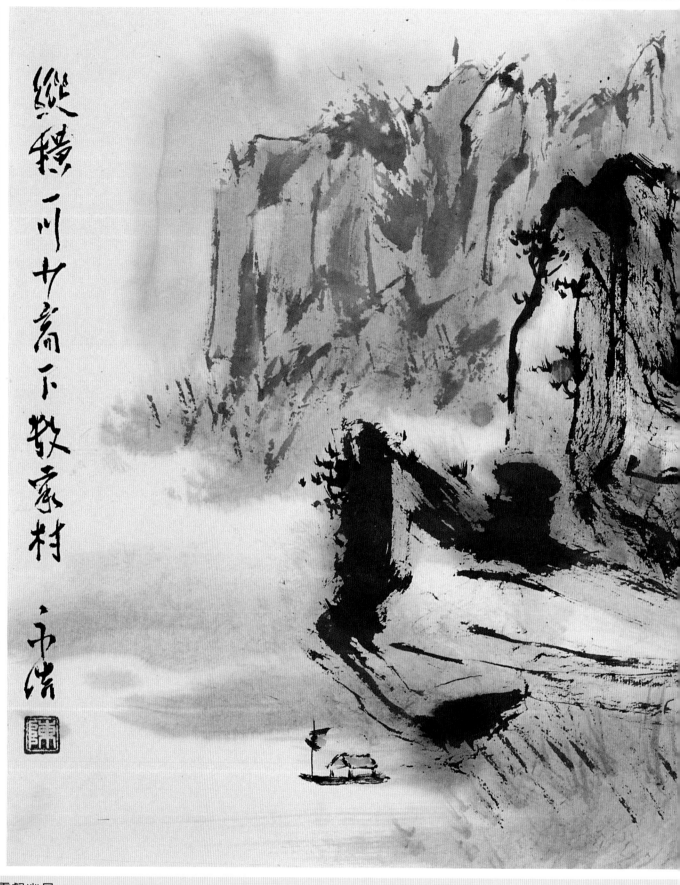

縱橫一川廿齋下數家村

市澔

雲壑幽居
Desolate Hermitage in Mountains
Ind and color on paper.

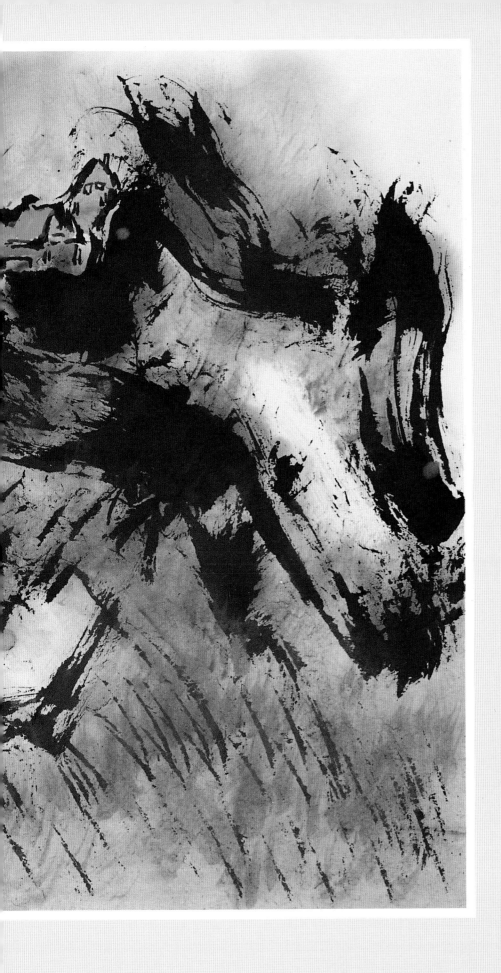

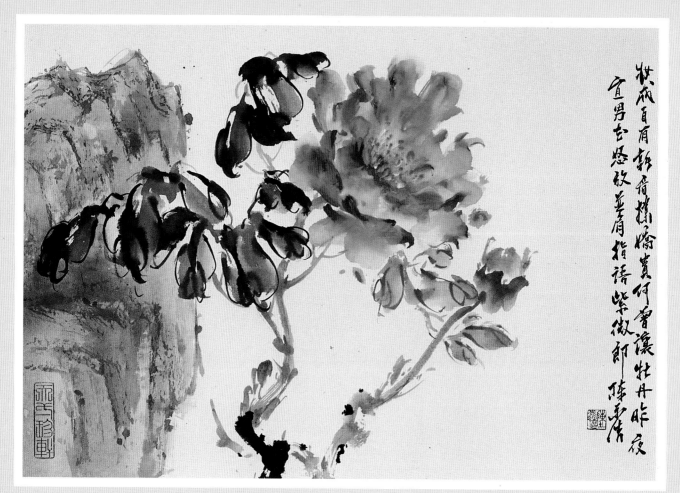

富貴來考

Peony and Ruok

Ind and color on paper.

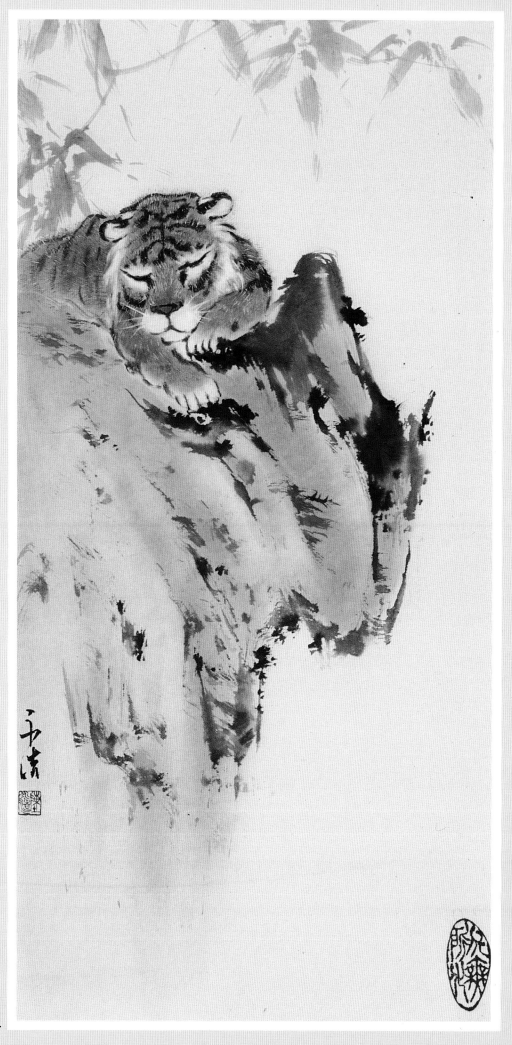

盹

Napping

Ind and color on paper.

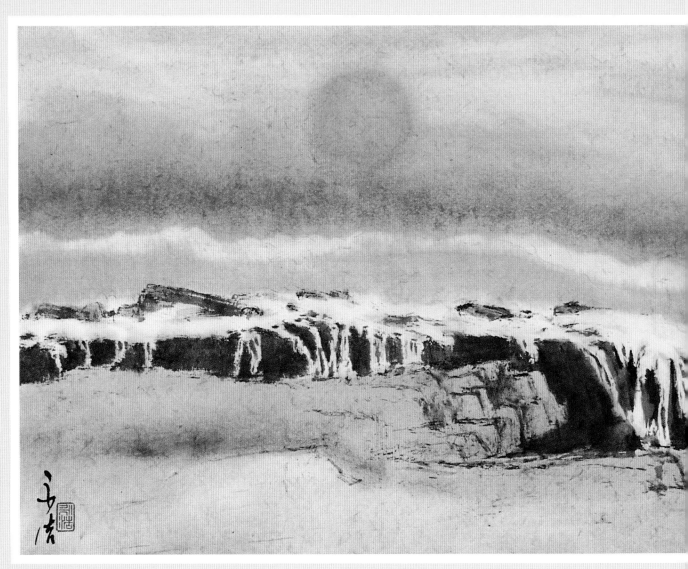

亂石崩雲
Rocks and Billow
Ink and color on paper.

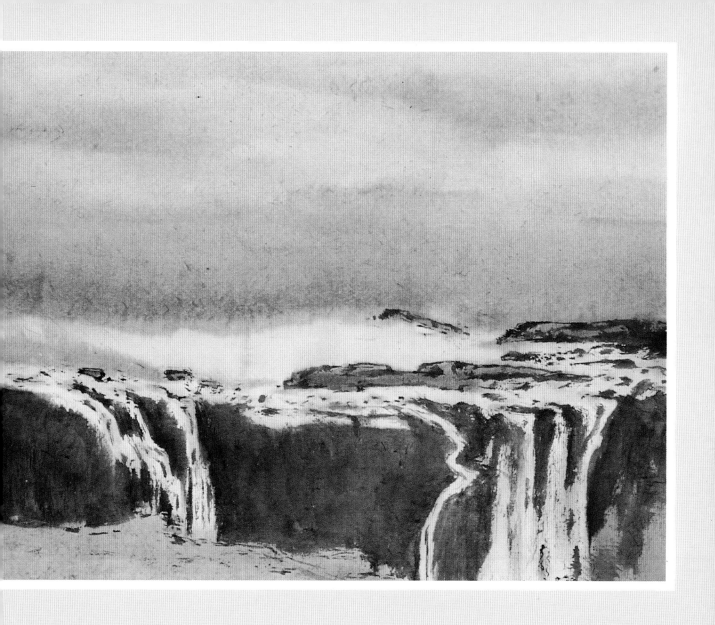

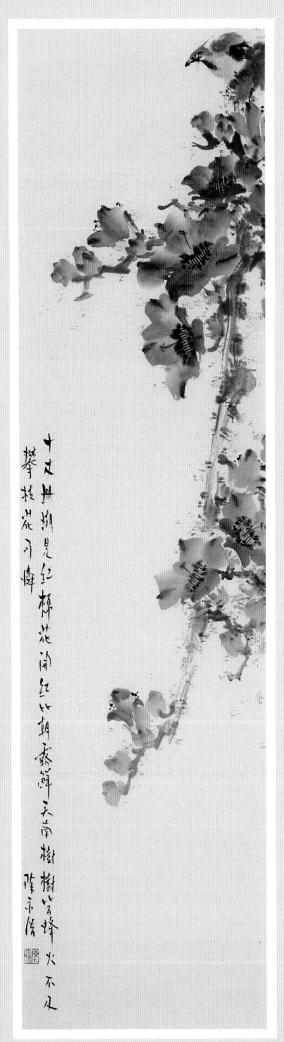

木棉
Blossoms
Ink and color on paper.

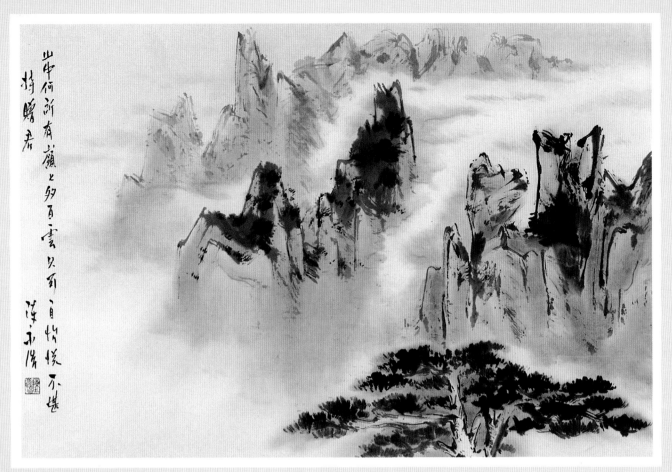

數峰出雲間

Clondy Mountains

Ink and color on paper.

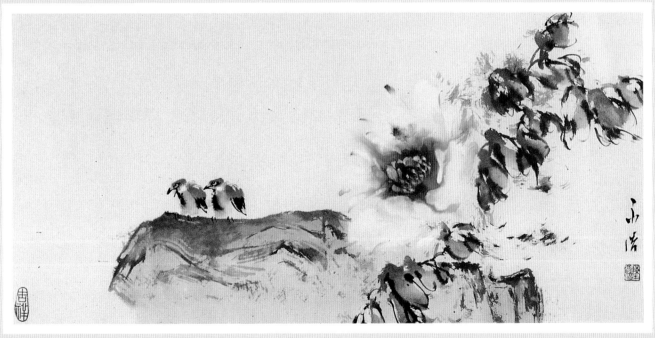

牡丹 Peony

Ink and color on paper.

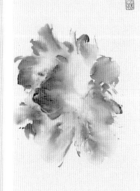

芳菲消息近如何白首浪蝶疑是黄人莫病起道裝半著淡紅絕陳立慶

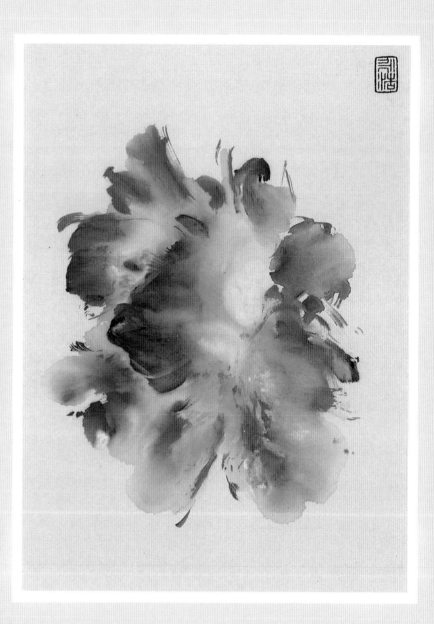

固一身之清也
The fallen kapok
Ink and color on paper.

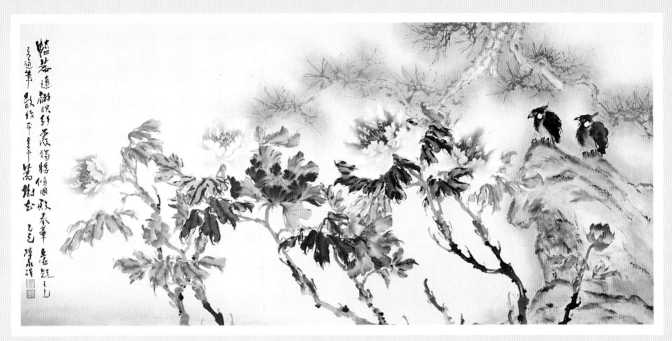

人間第一香

Peony

Ink and color on paper.

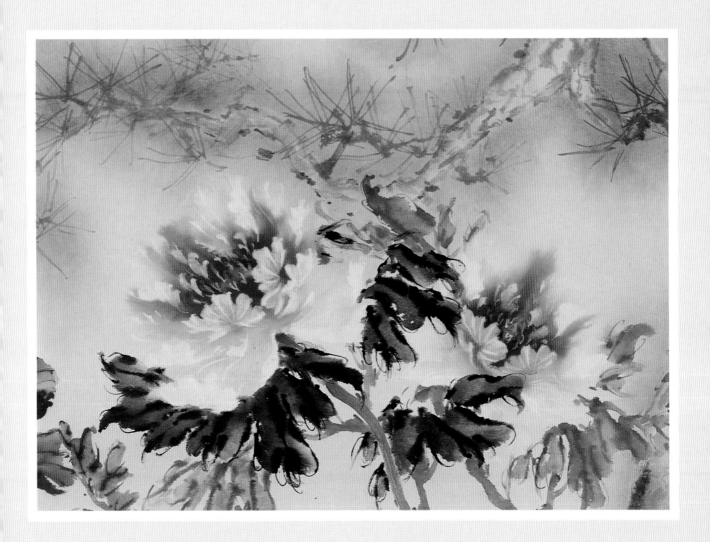

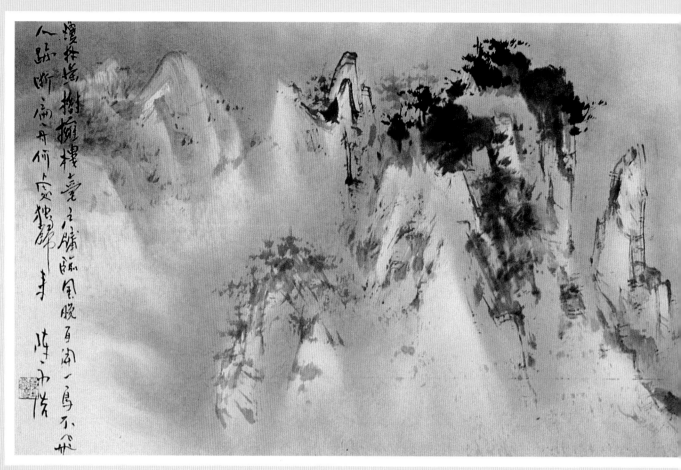

寒山踏雪
Snow Trarelling in Wintry Monntains
Ink and color on paper.

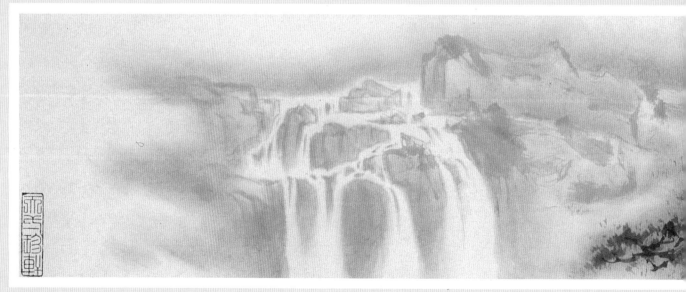

瀑影
Waterfall
Ink and color on paper.

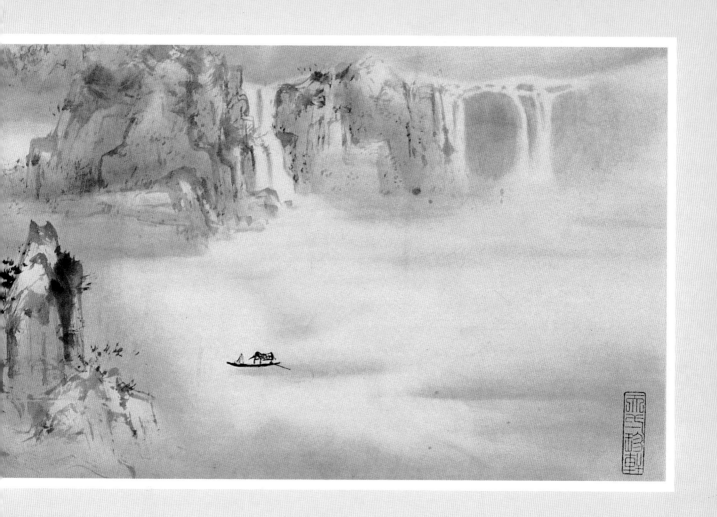

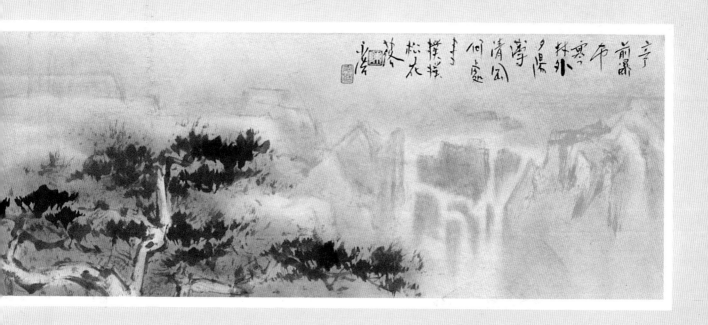

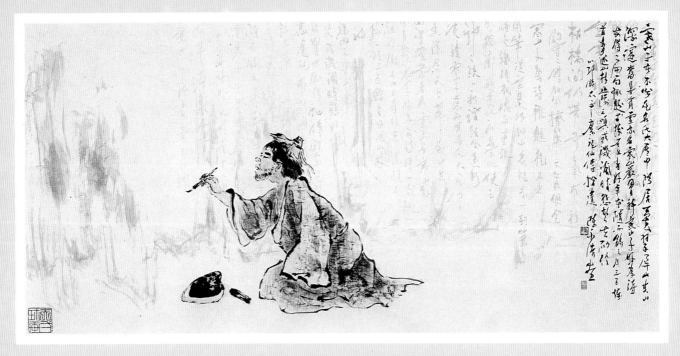

寒山子題壁
Han shan.a chan Puet of hte tang Dynasty
Ink and color on paper.

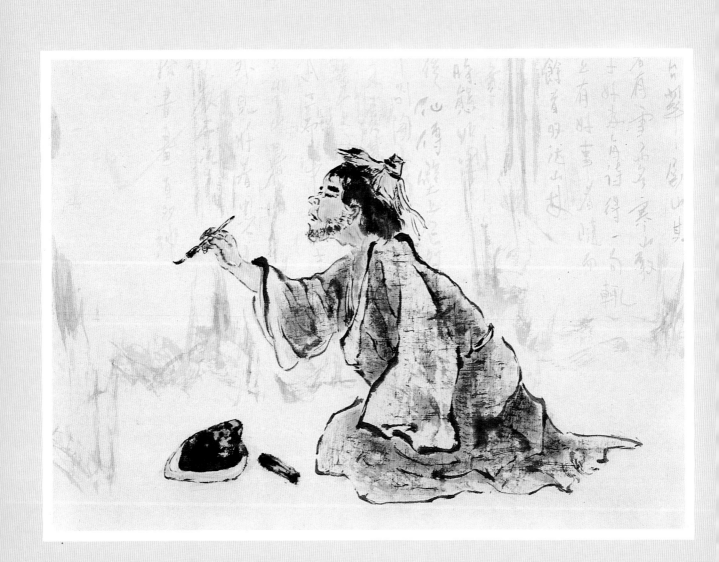

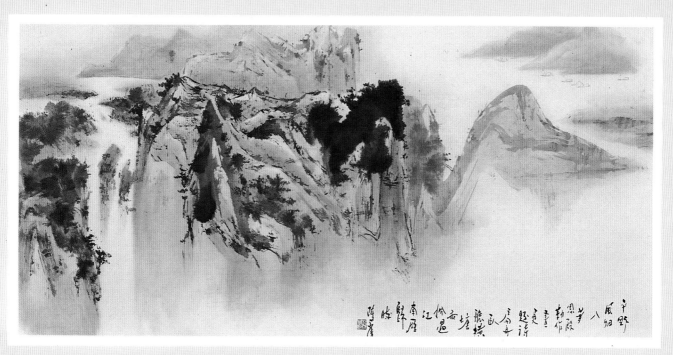

潤浦遙山
Land And River Seen Afar
Ink and color on paper.

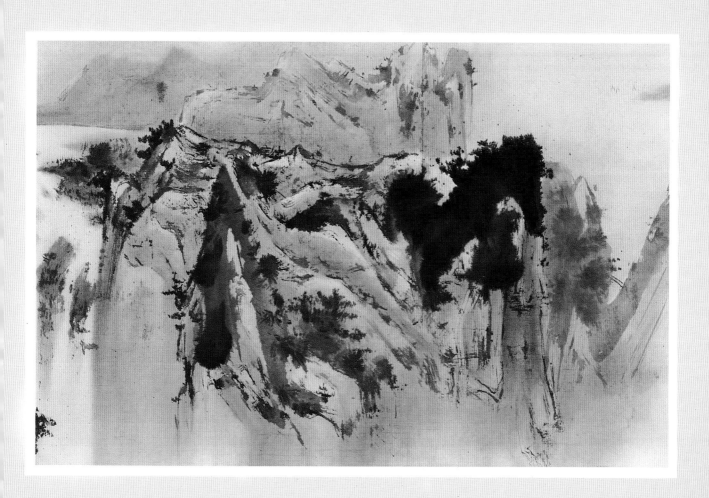

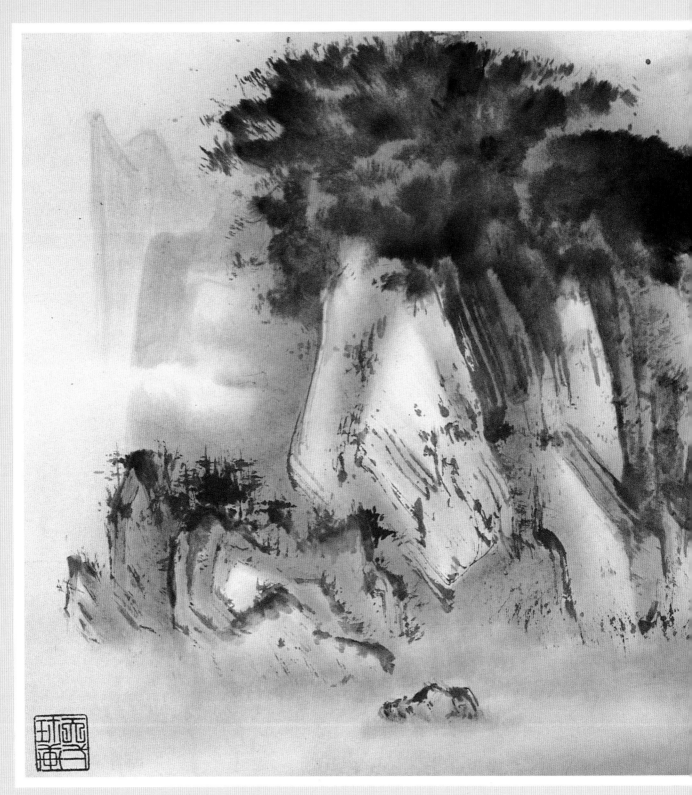

溪山清夏
summer Monntains
Ink and color on paper.

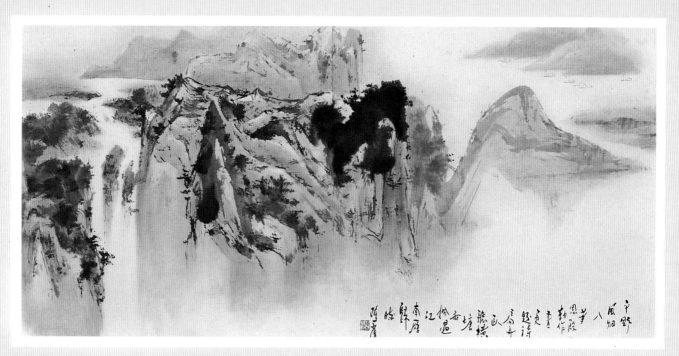

潤浦遙山
Land And River Seen Afar
Ink and color on paper.

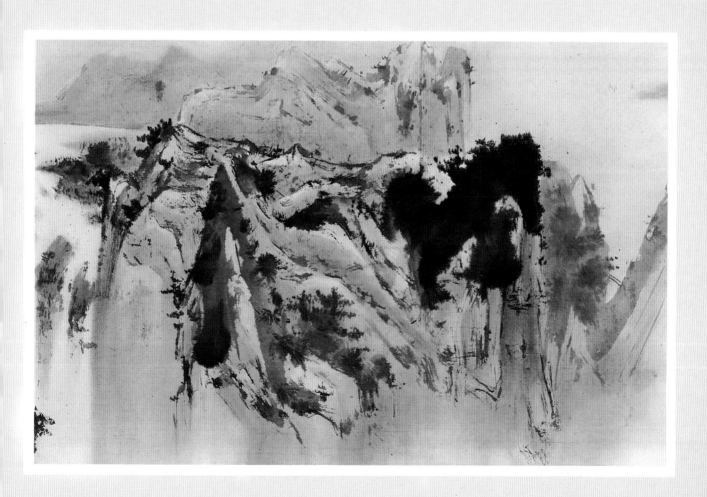

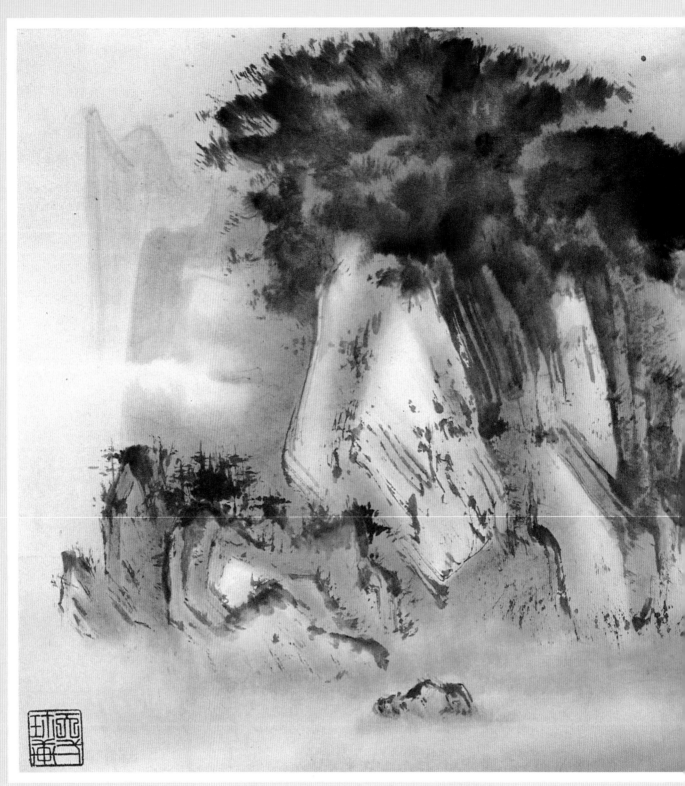

溪山清夏
summer Monntains
Ink and color on paper.

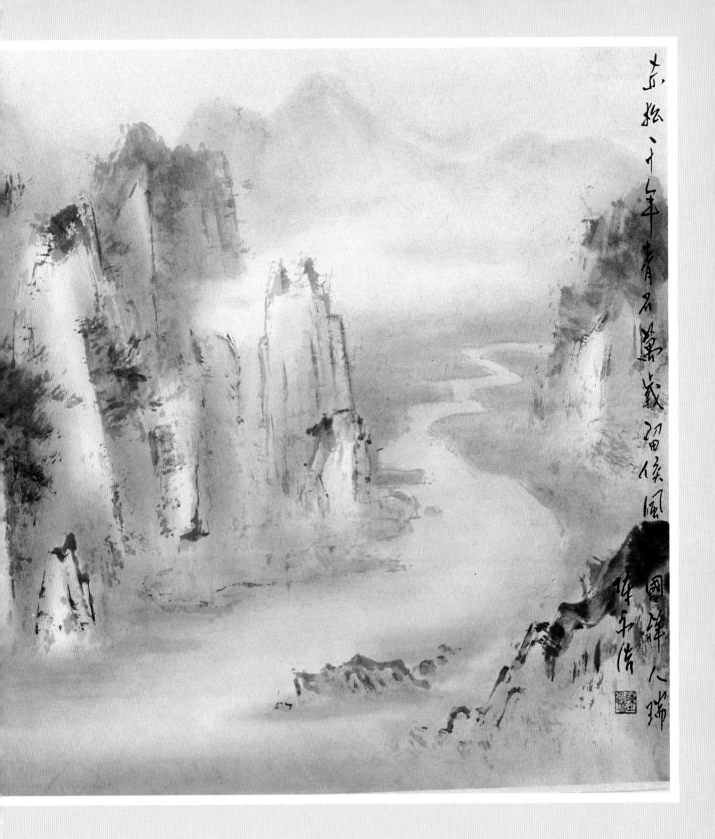

赤松千年青石萬歲智傲風
國鋒人瑞　陳平浩

69

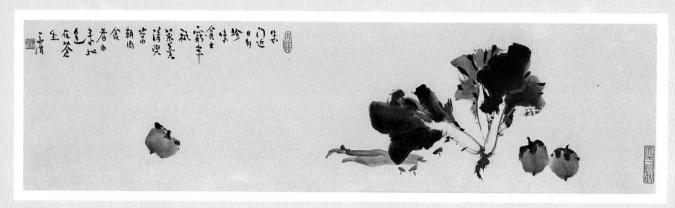

根香
Vegetables
Ink and color on paper.

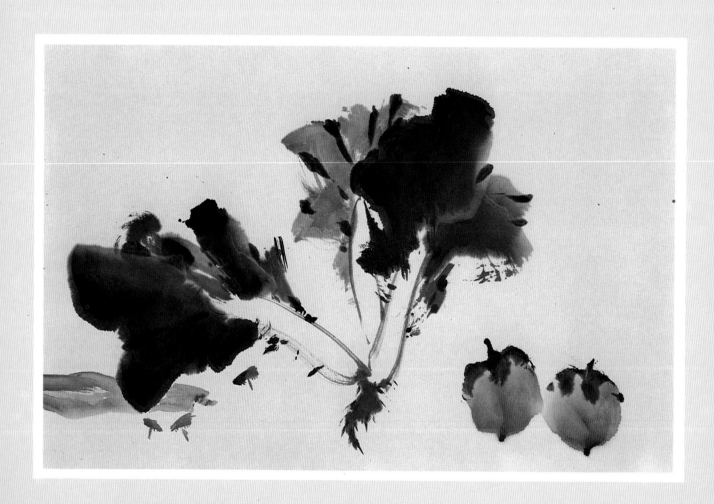

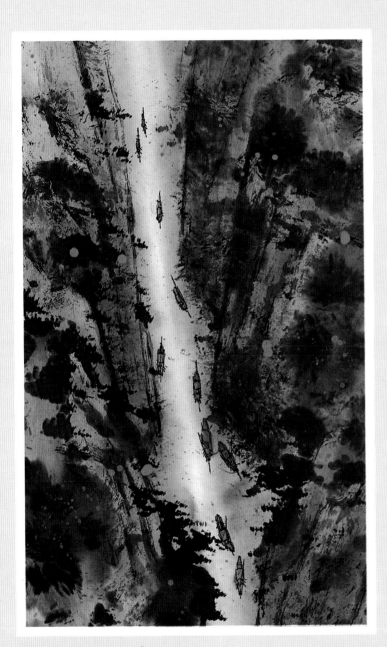

秋浦歸舟
Returning sail
Ink and color on paper.

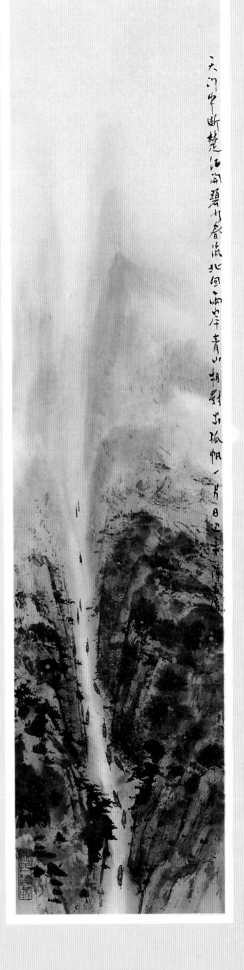

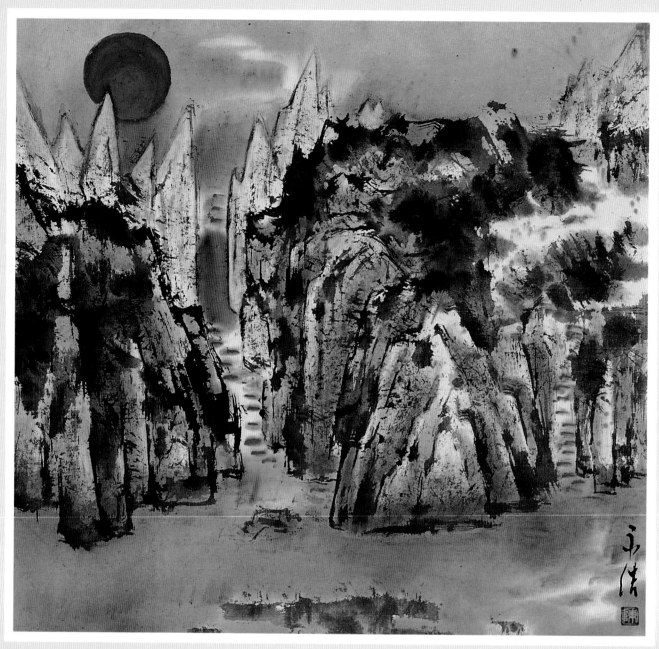

秋溪暮色
Autumn Scenery at Nightfall
lnd and color on paper.

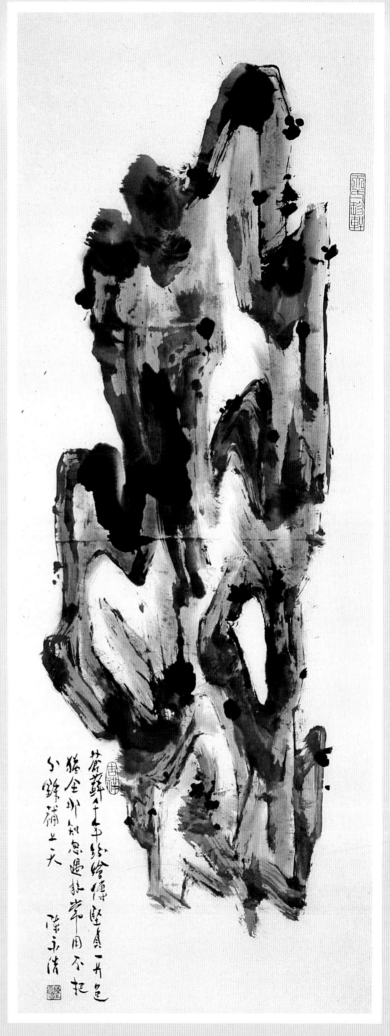

石

Stone

Ind and color on paper.

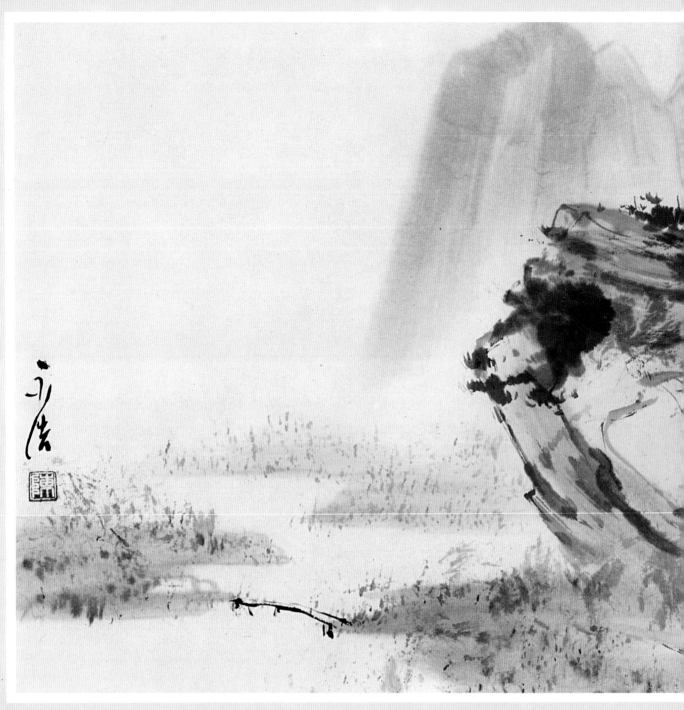

湖畔

Lakeside scene

Ind and color on paper.

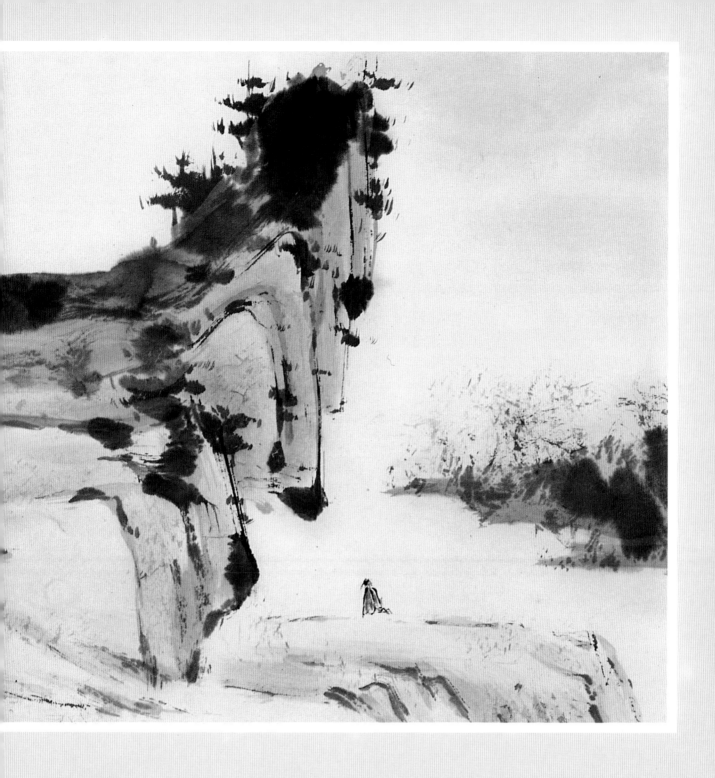

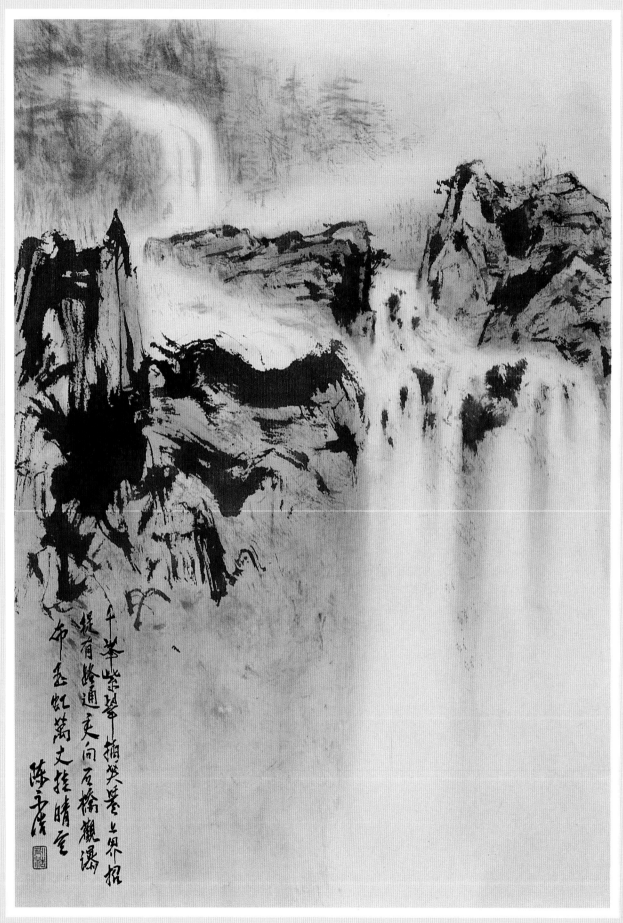

重泉

Flush After Rain

Ink and color on paper.

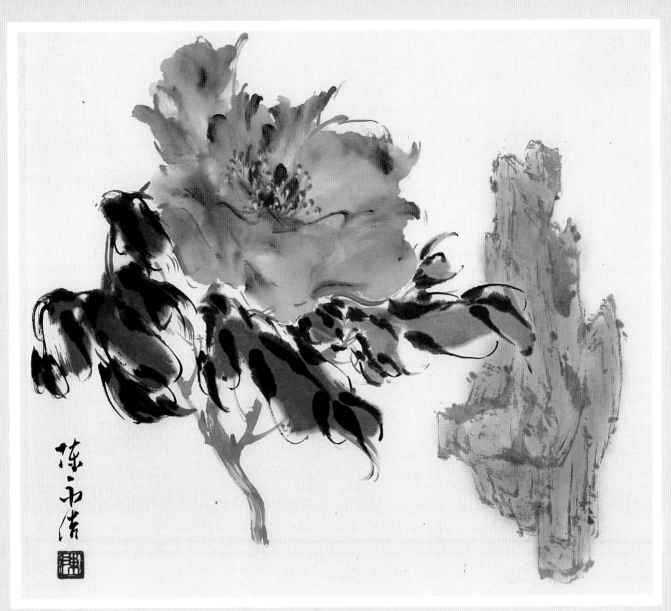

牡丹
Peony
Ink and color on paper.

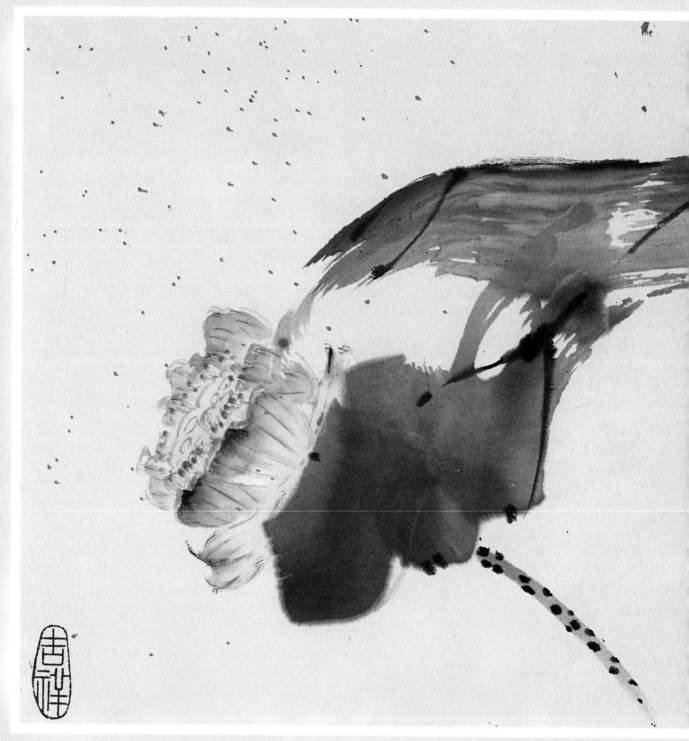

荷
Lotus
Ink and color on paper.

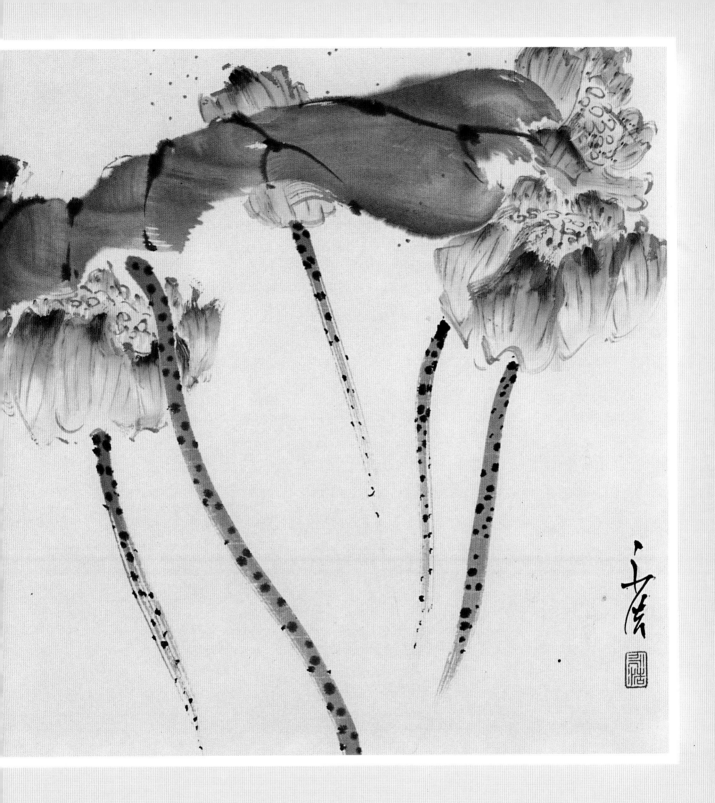

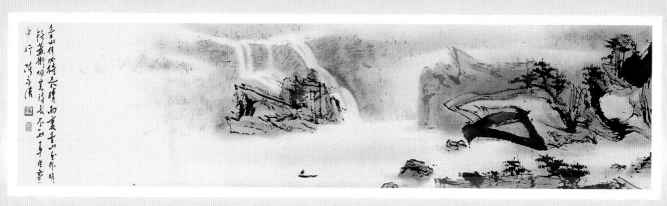

空谷流泉
Desolate Valley and Flowing Streams
Ind and color on paper.

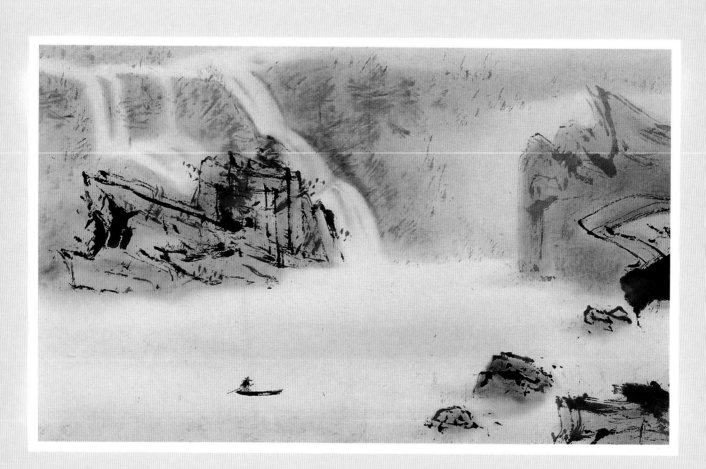

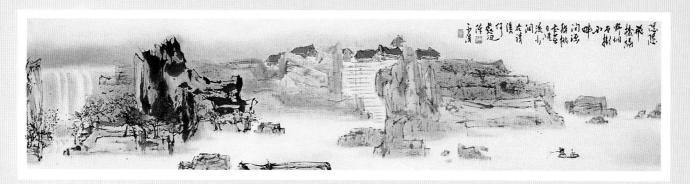

秋溪曉渡
Crossing a Creek at Dawn in Autumn
Ind and color on paper.

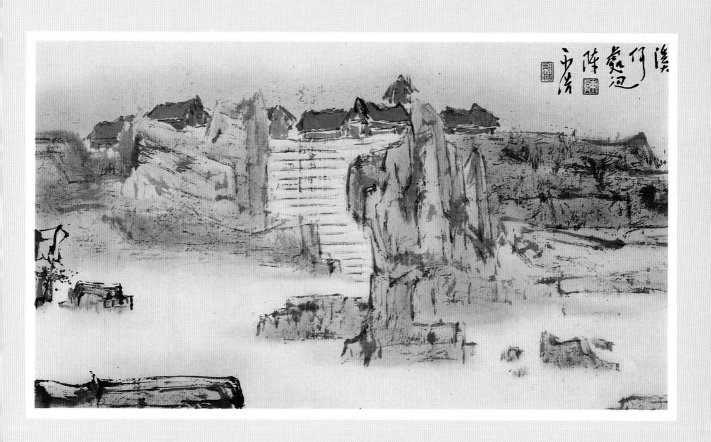

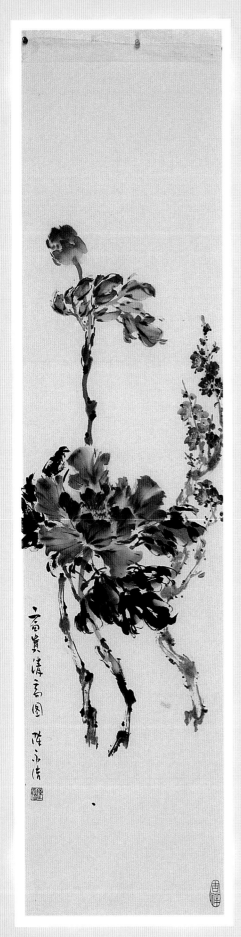

春
Spring
Ind and color on paper.

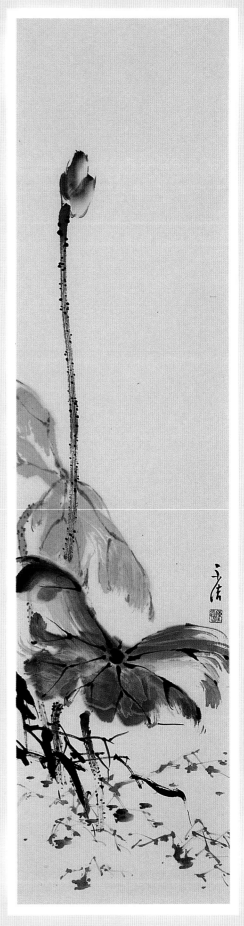

夏
Summer
Ind and color on paper.

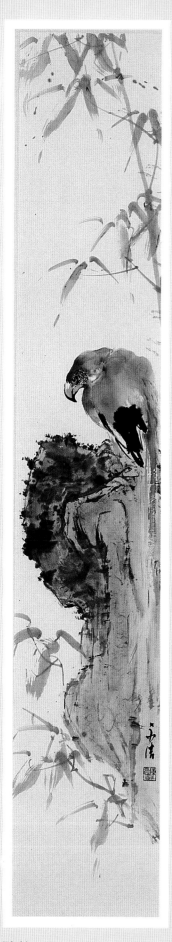

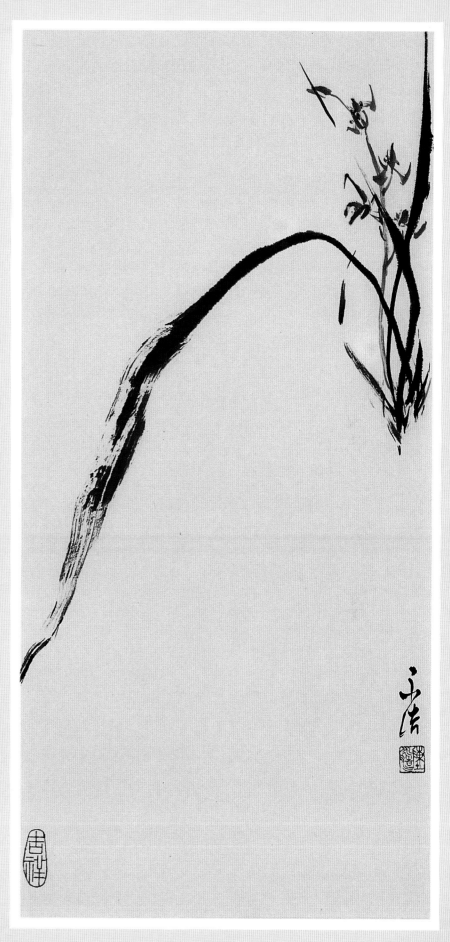

鸚鵡

Parrot

Ind and color on paper.

臨風

Ode to the wind

Ind and color on paper.

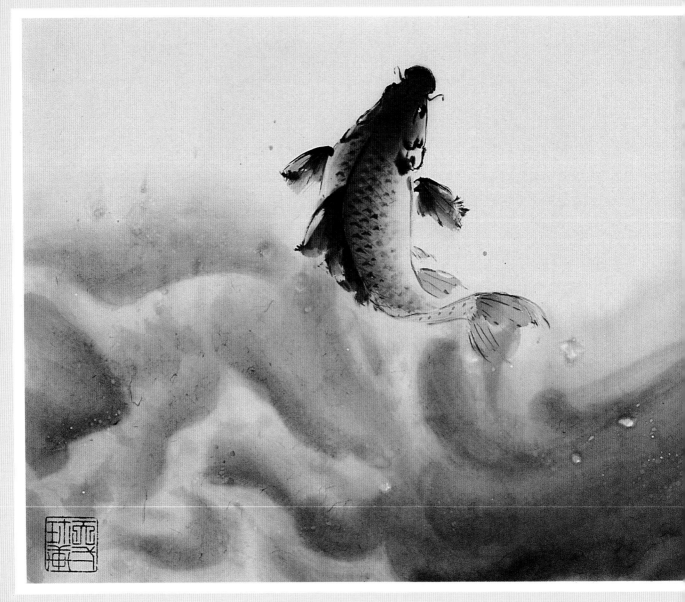

春江躍鯉
Fish
Ind and color on paper.

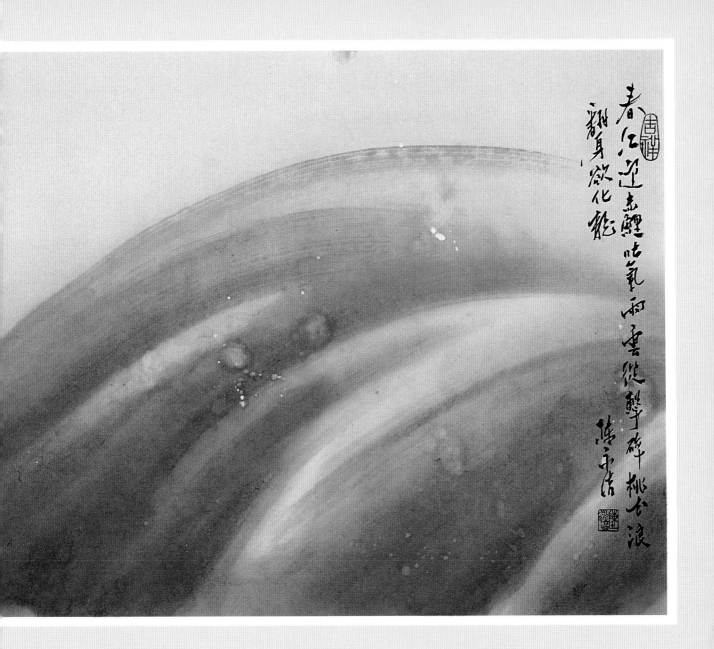

春江迎送幾多情

吐氣兩雲從擊手

碎桃長浪

翻身欲化龍

陳呈清

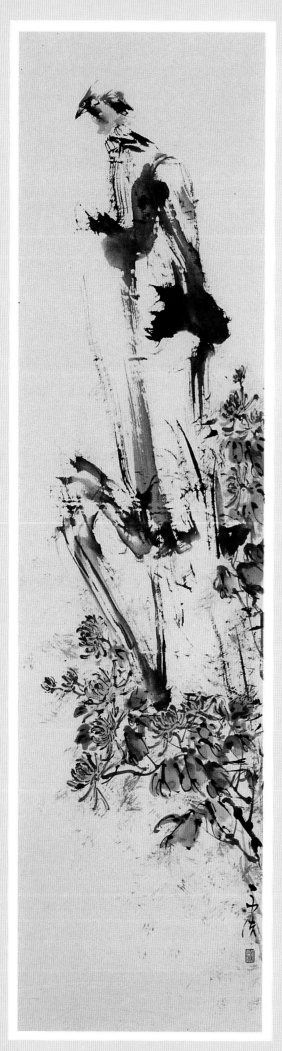

秋
Antumn
Ink and color on paper.

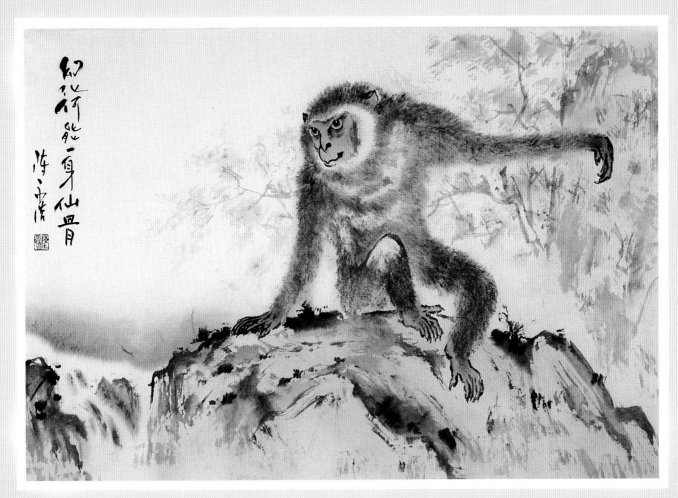

猿憩

Monkey

Ink and color on paper.

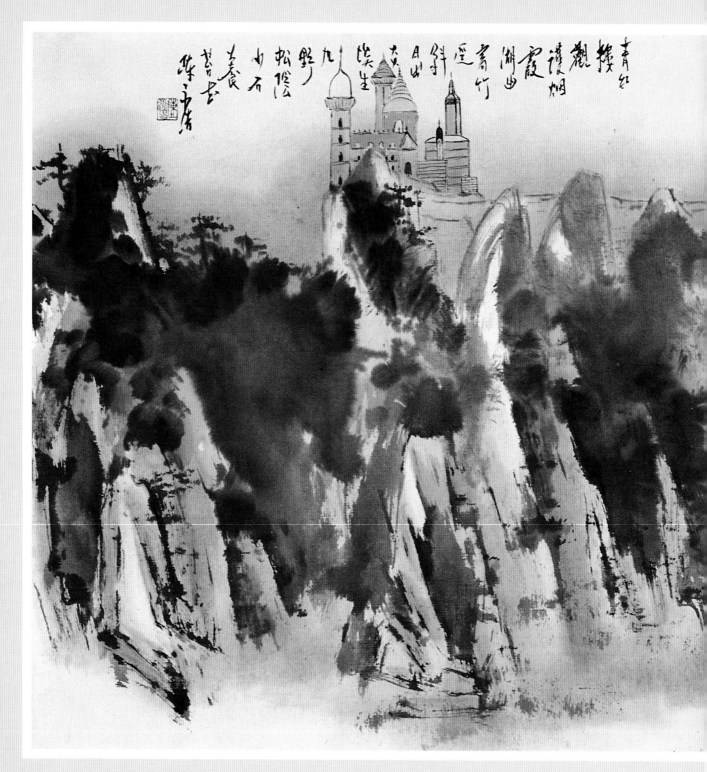

高岩古堡
Old Monastery In the Hills
Ink and color on paper.

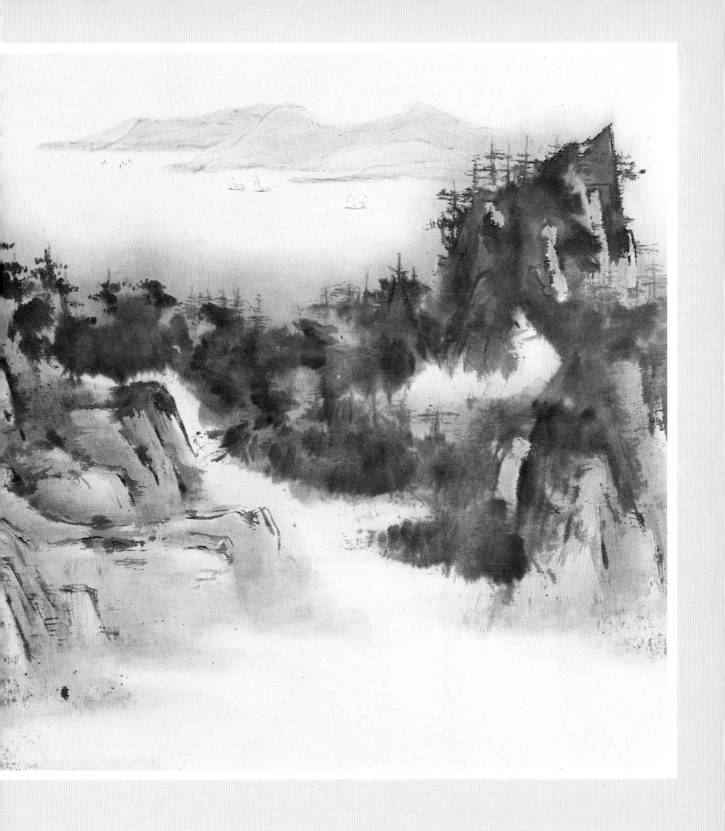

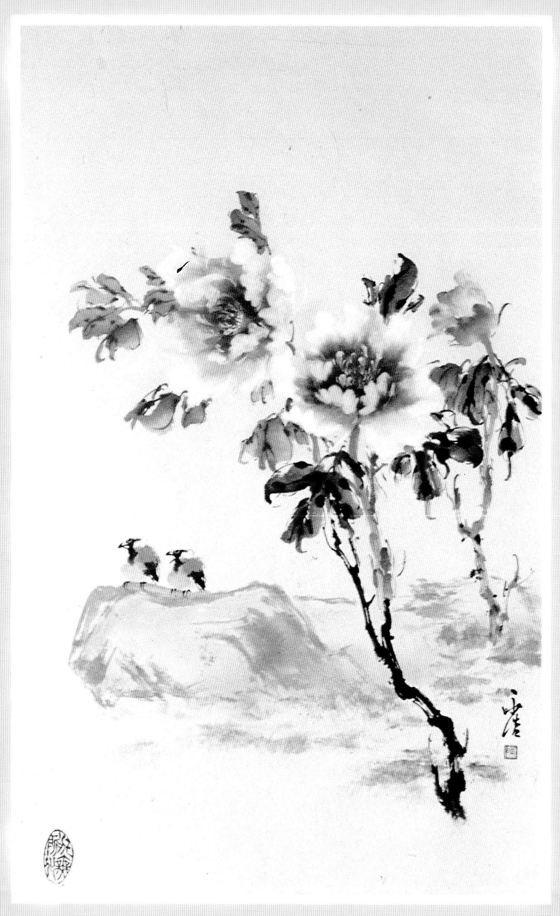

富貴白頭

Peony

Ink and color on paper.

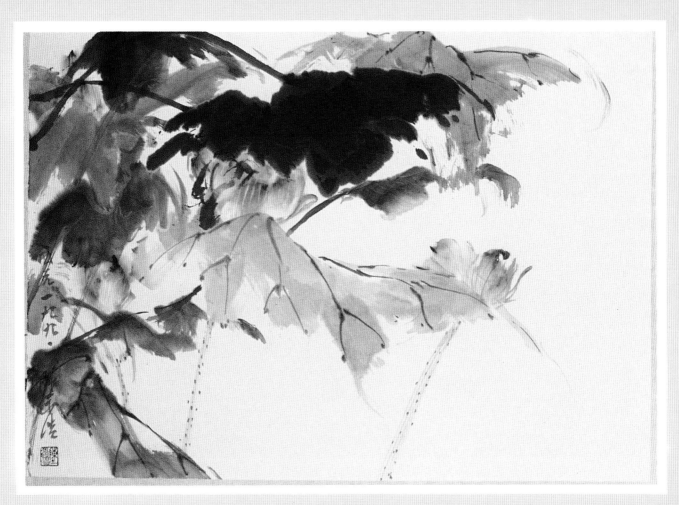

荷花
Lotus
Ink and color on paper.

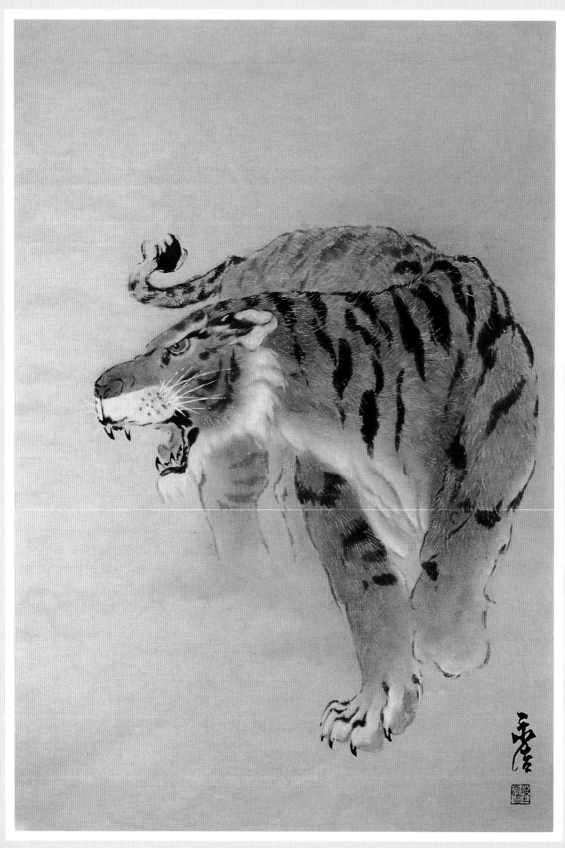

虎
Tiger
Ink and color on paper.

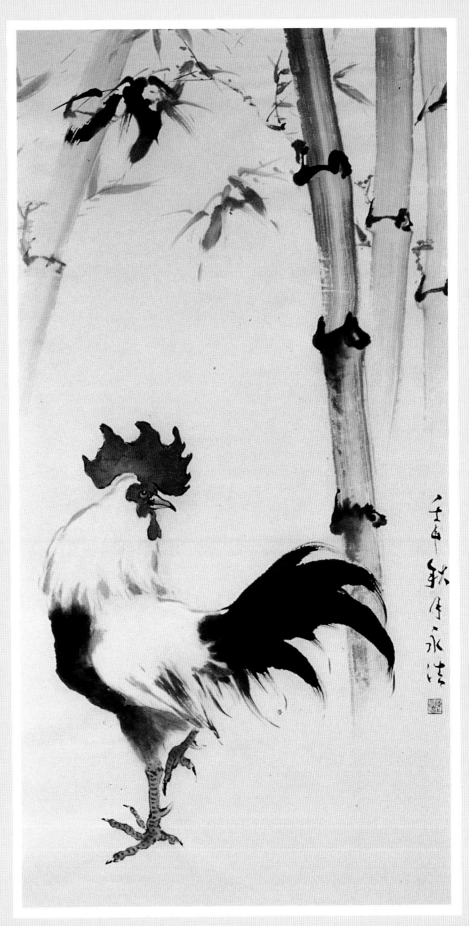

雞

Rooster

Ink and color on paper.

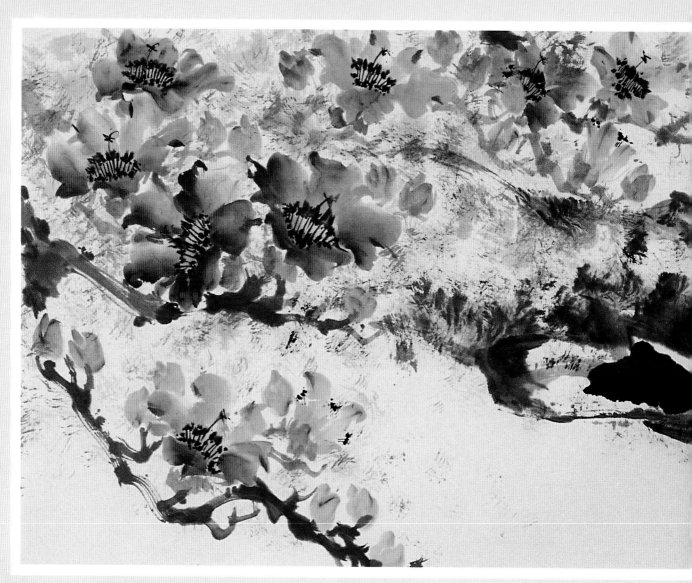

木棉紅占嶺南春
Kapok Aflame
Ink and color on paper.

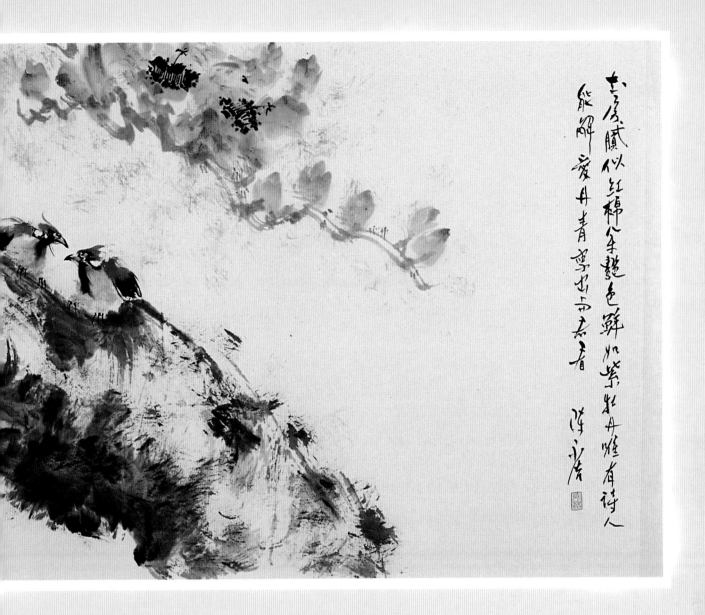

木芙蓉似紅棉朵朵艷色鮮如紫牡丹唯有詩人
能解愛丹青寫出兩爭看　梁雪　[印]

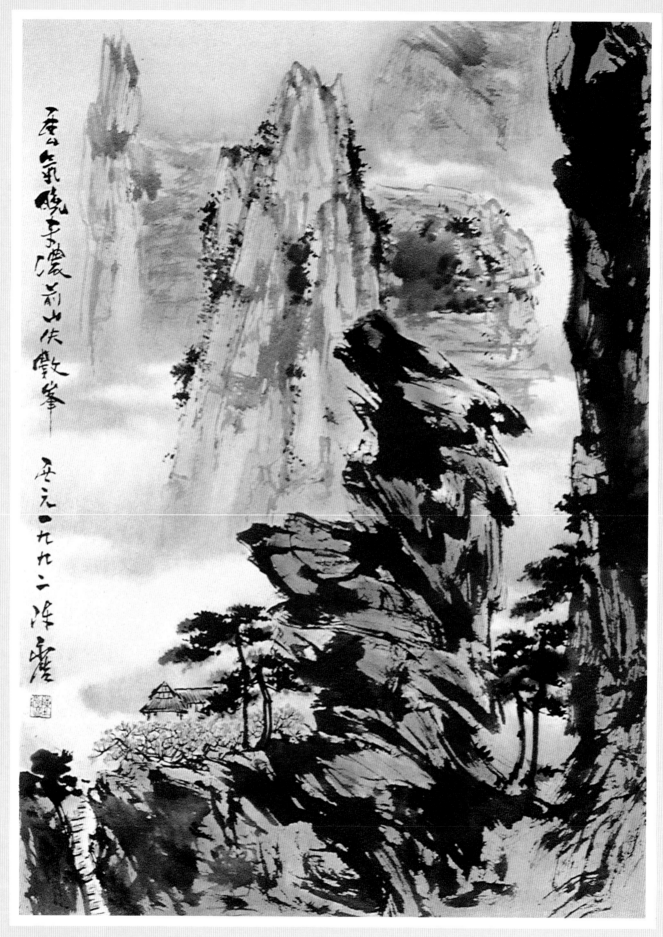

新秋暮色

Autumn Scenery at Dusk

Ink and color on paper.

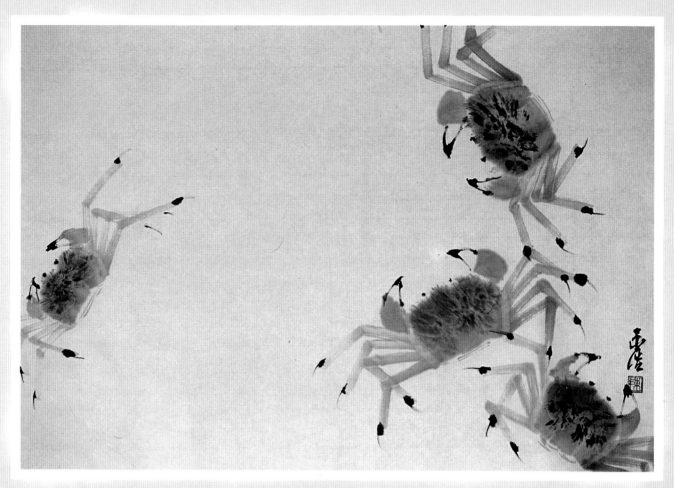

蟹

Crab

Ink and color on paper.

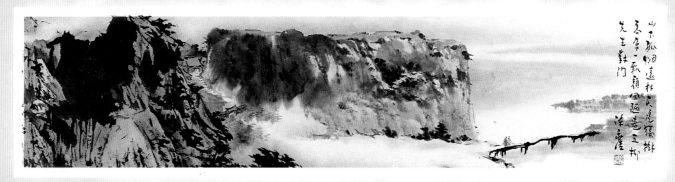

春山疊翠
green Monntains in Spring
lnd and color on paper.

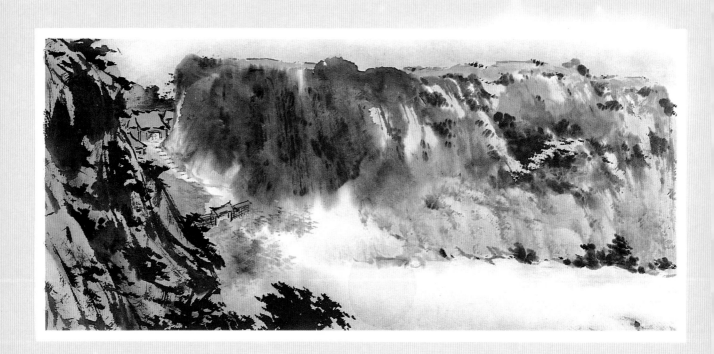

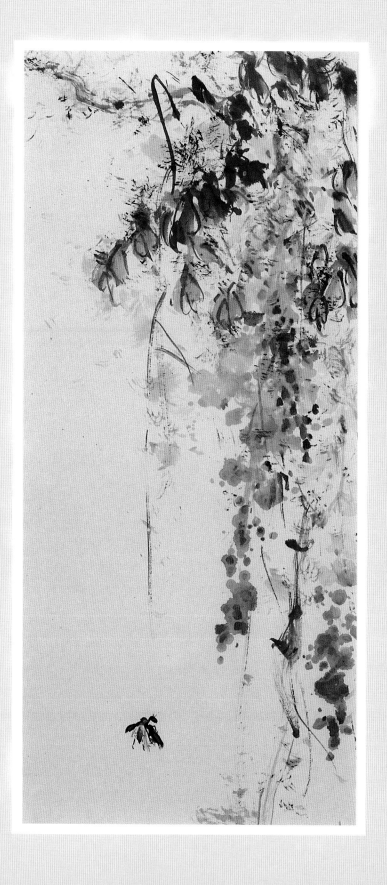

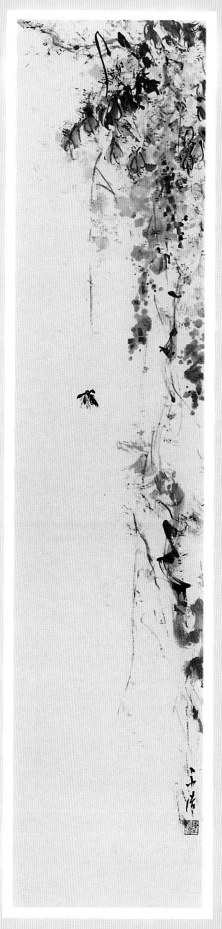

紫氣

A clond of Purple

Ind and color on paper.

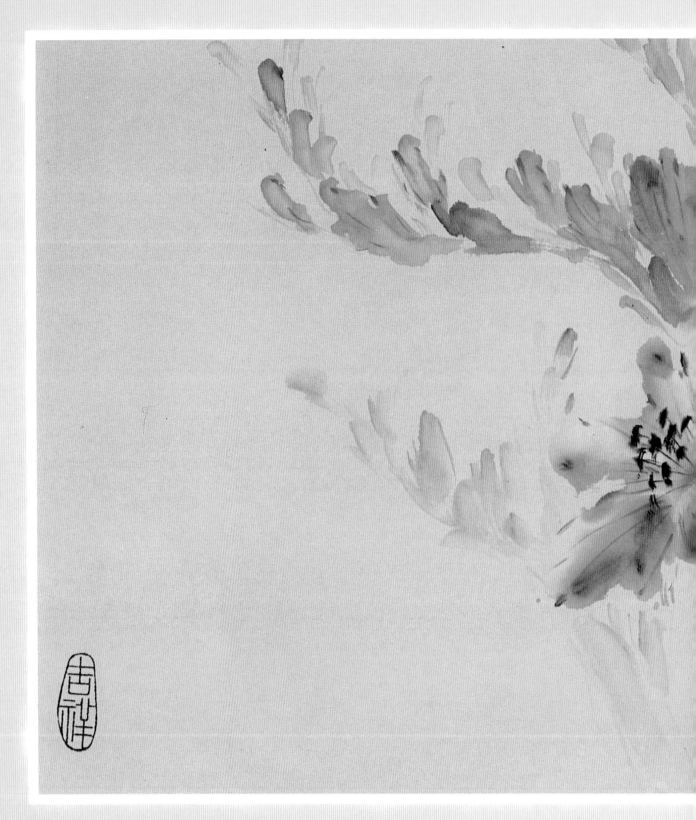

花
Flowers own
Ink and color on paper.

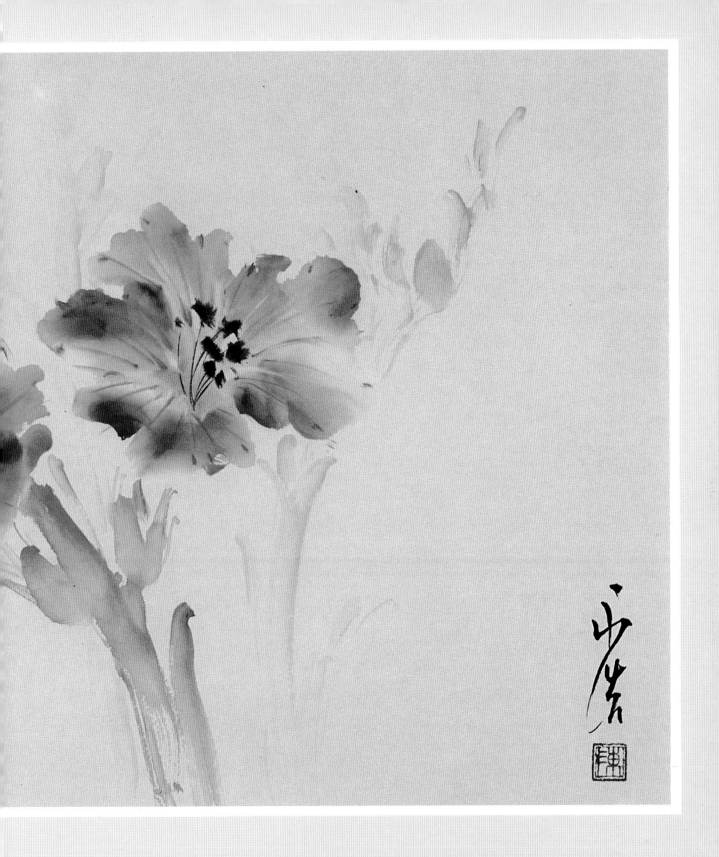

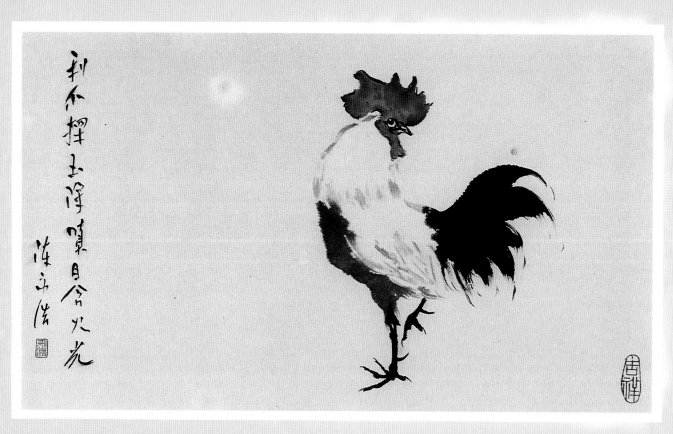

雞
Dawn Herald
Ink and color on paper.

只要我長大
If Only I Grow up
Ink and color on paper.

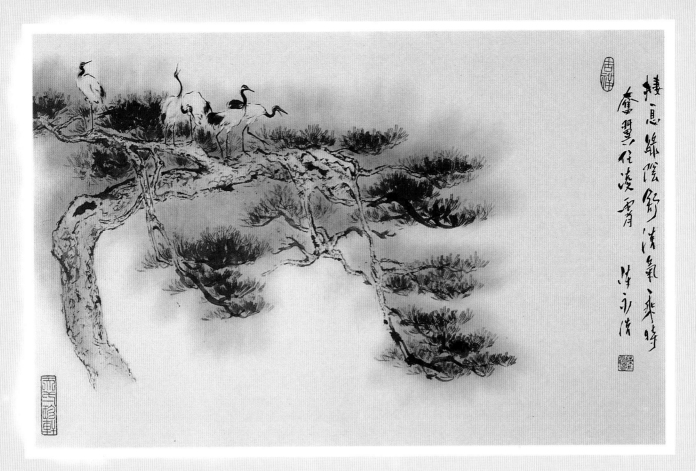

松鶴延年

Pine and Crane

Ink and color on paper.

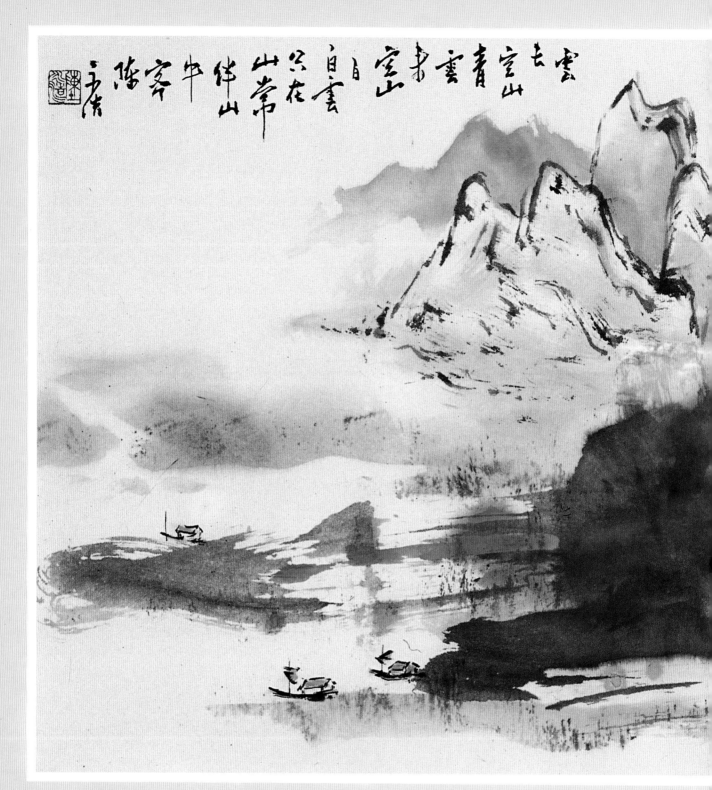

溪山疊嶂
Mounfains and streams
Ind and color on paper.

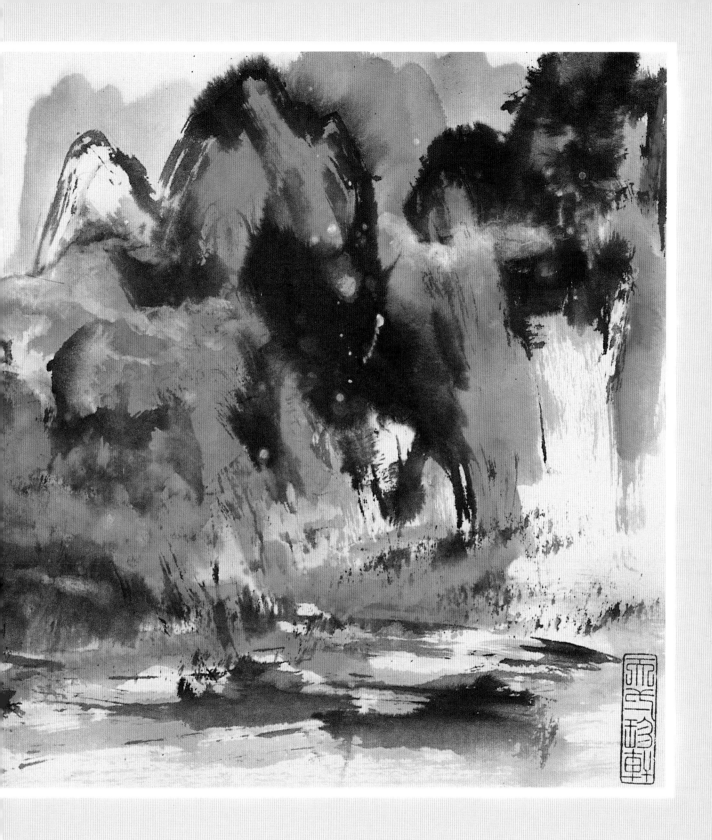

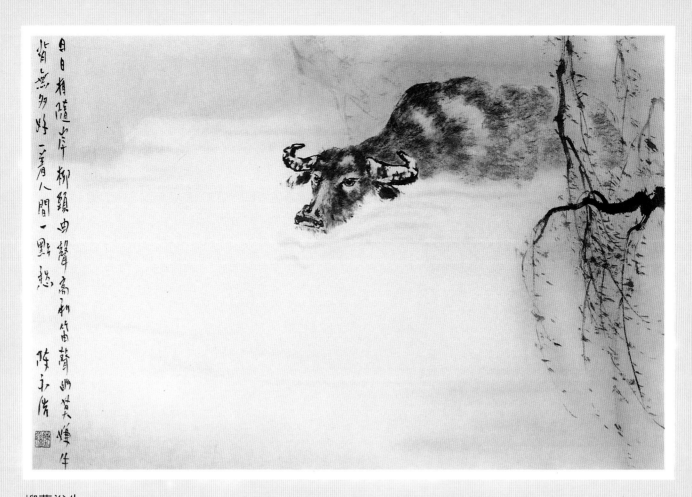

柳蔭浴牛
Buffalo Bathing Under the willow
Ink and color on paper.

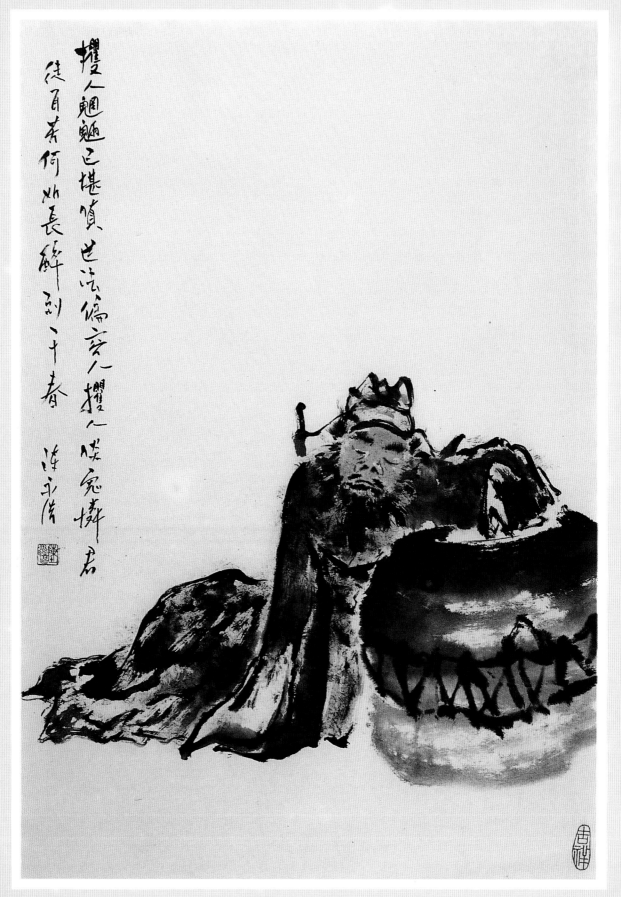

攫人魍魎已堪憤
世法偏容人攫人
咲冤撐君
徒有苦何如長醉
到千春
陳永陪

鍾馗倚醉

Intoxicated chung Kuei—a Demon slayer

Ink and color on paper.

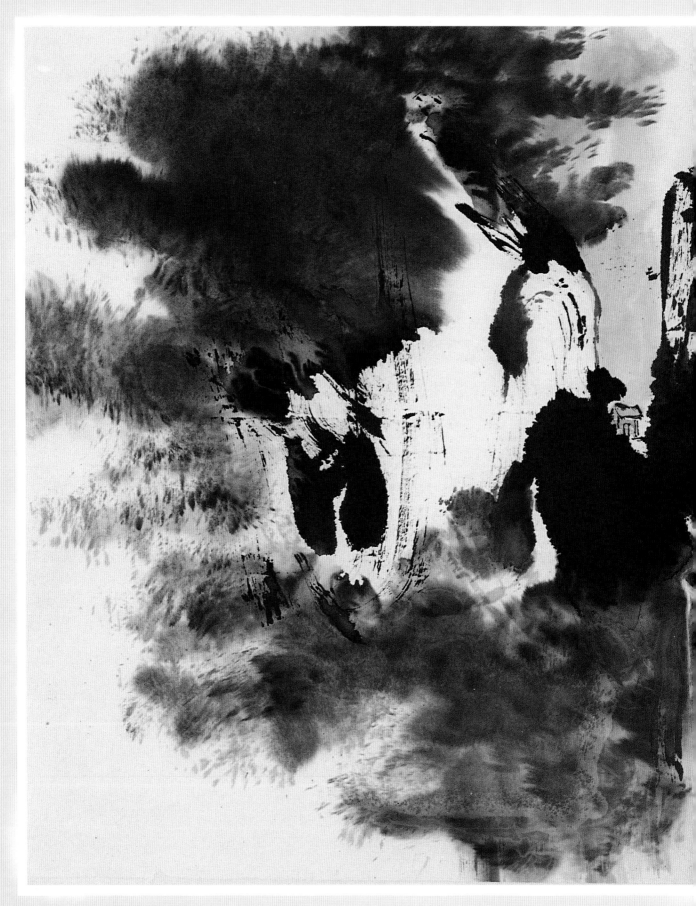

山居暮色
Mountain Habitat at Dusk
Ink and color on paper.

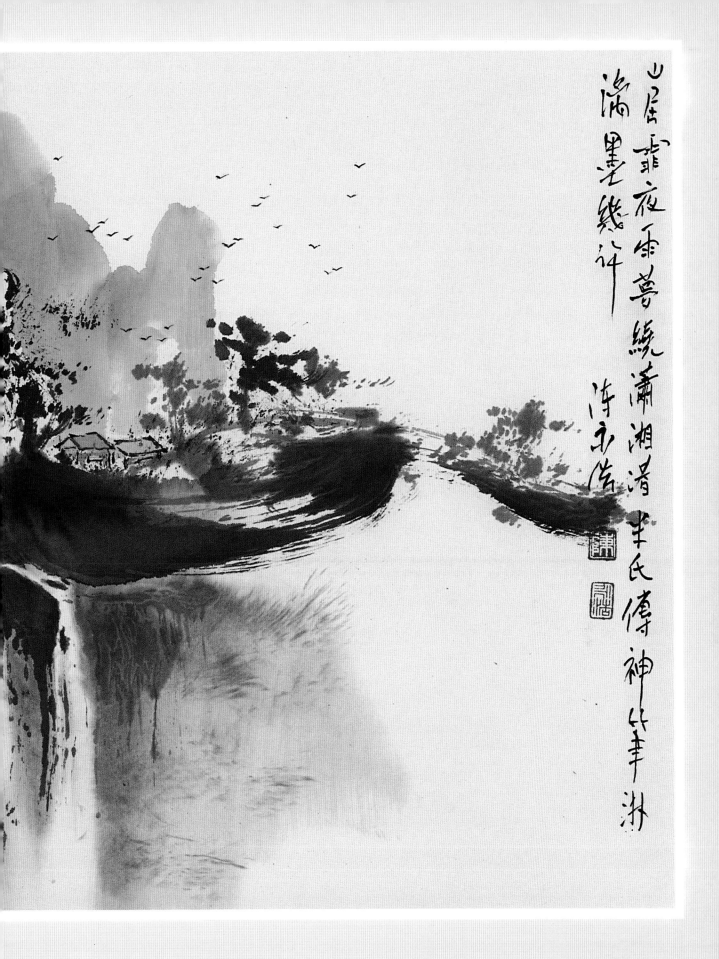

山居霏夜雨夢繞瀟湘潑半氏傳神兆筆淋漓墨幾許　陳永鏘

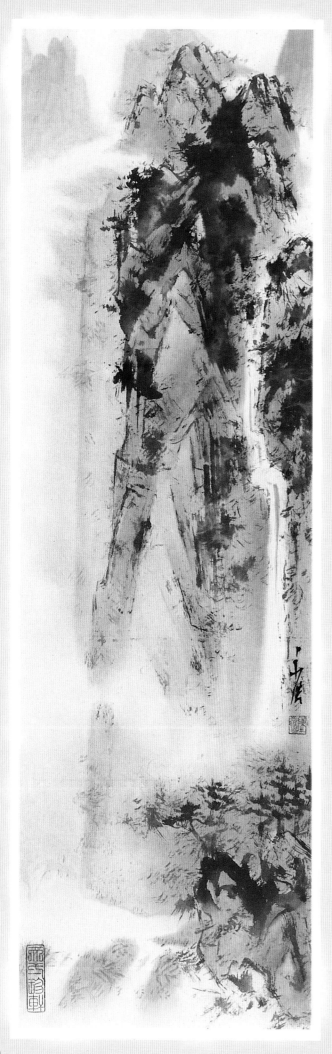

泉澗飛鳴
Waterfall
Ind and color on paper.

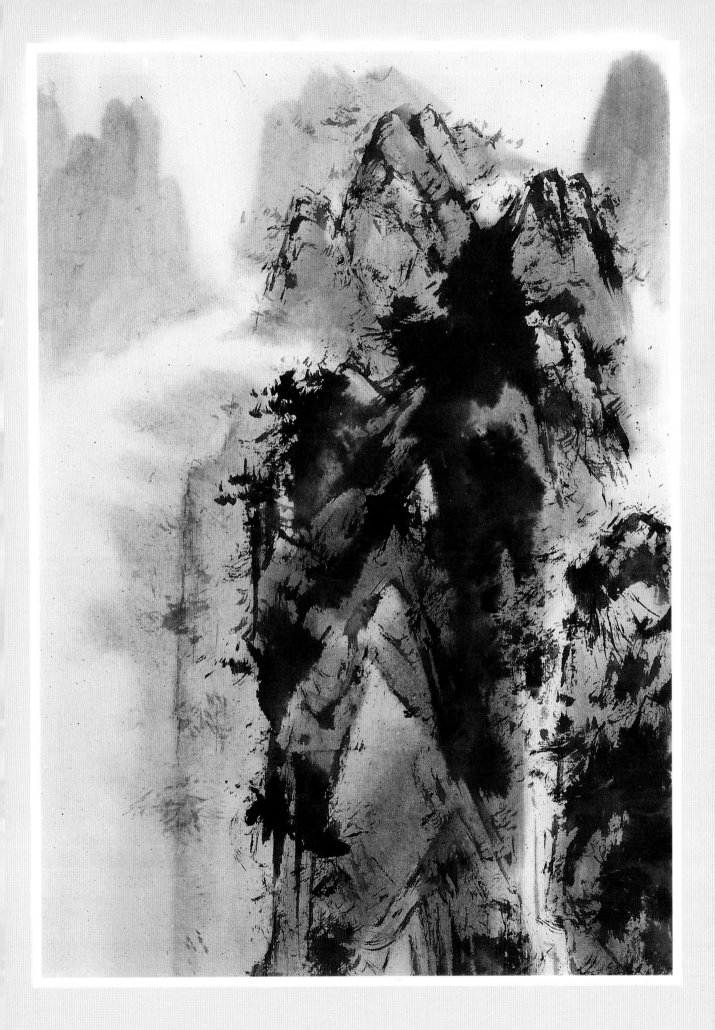

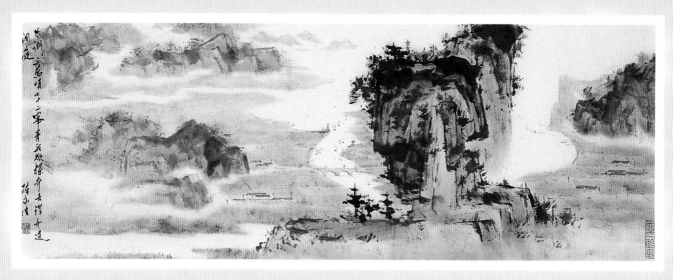

湖山清夏
summer Landscape
lnd and color on paper.

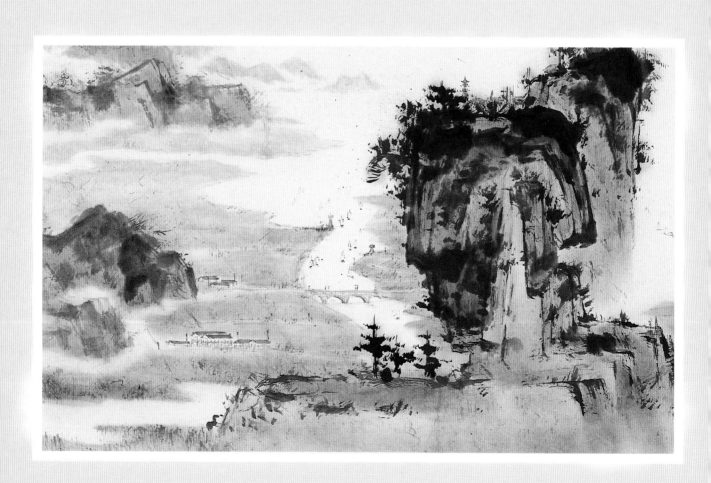

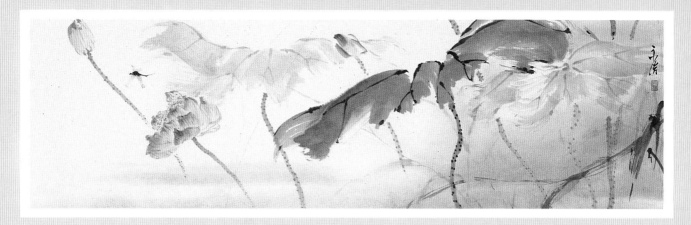

清聲

Chirping

Ind and color on paper.

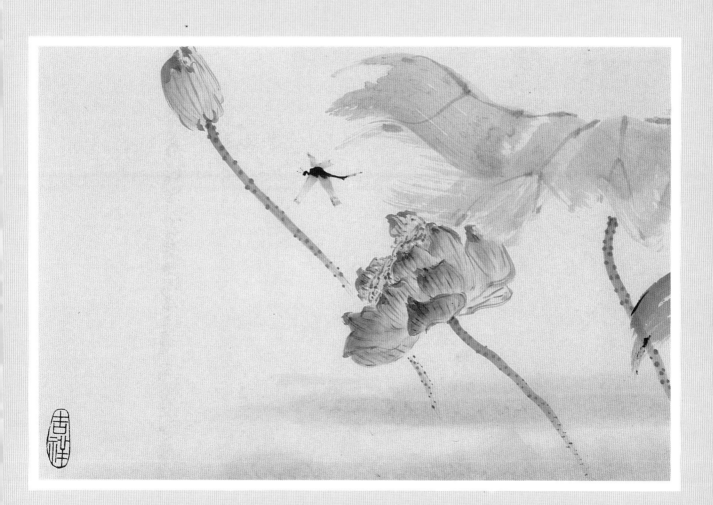

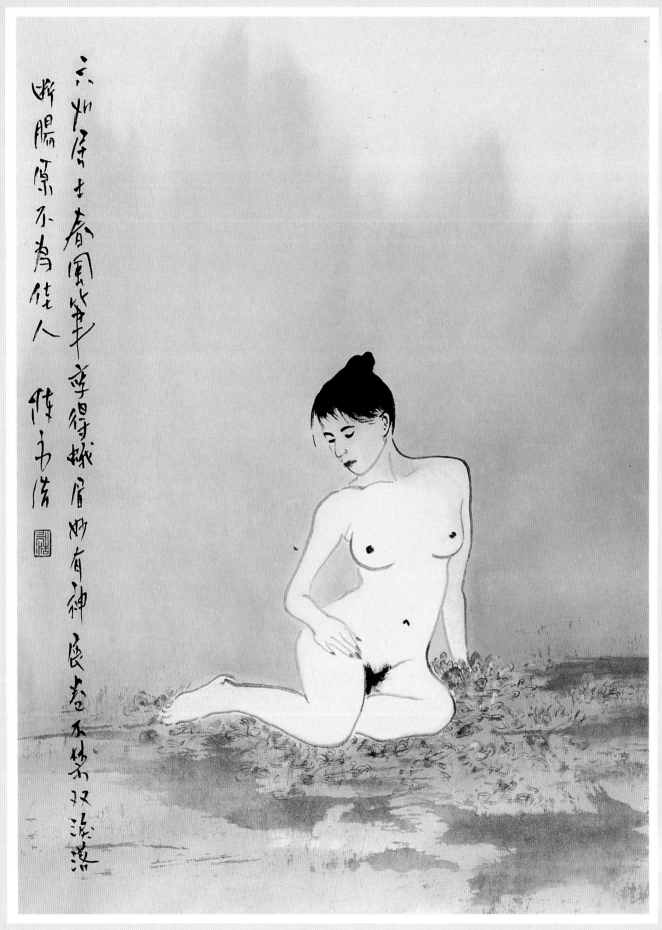

野草

Wild Grass

Ink and color on paper.

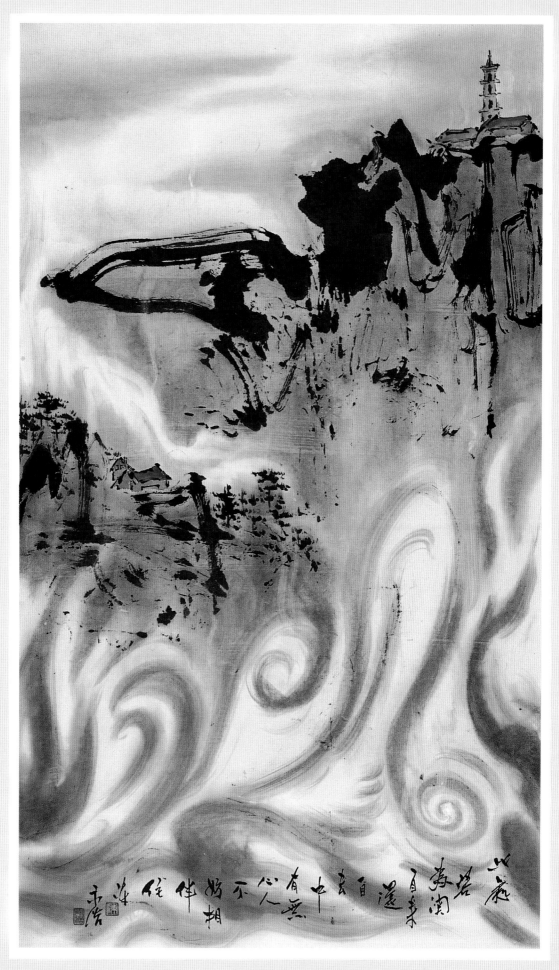

天光雲影

Sunshine and clouds

Ink and color on paper.

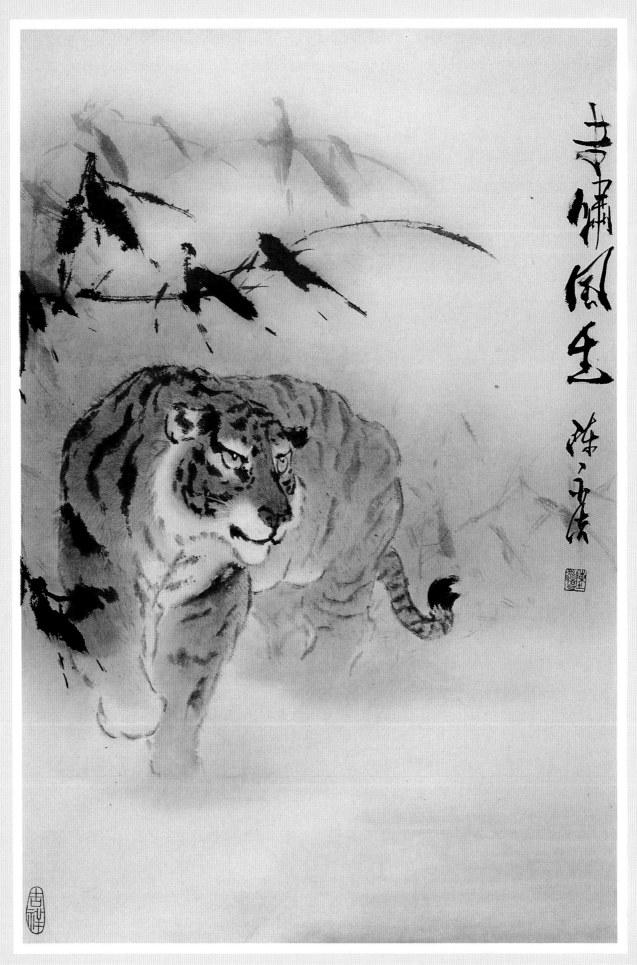

虎步
Tiger
Ind and color on paper.

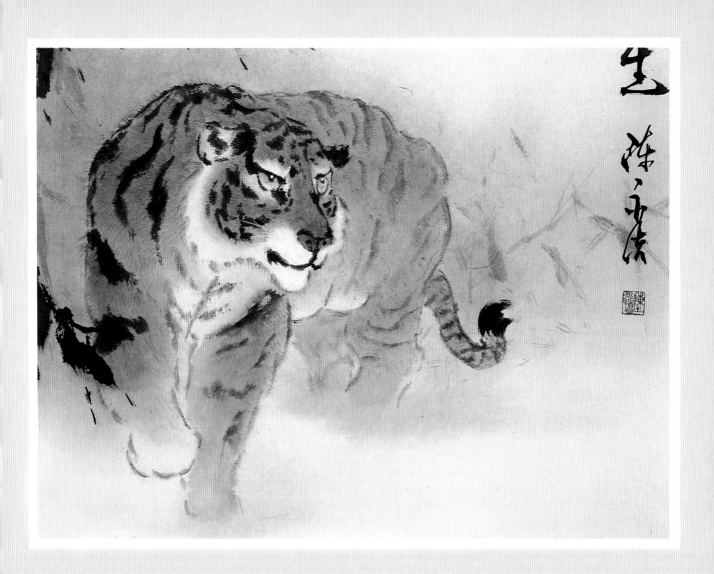

生

陳丹青

117

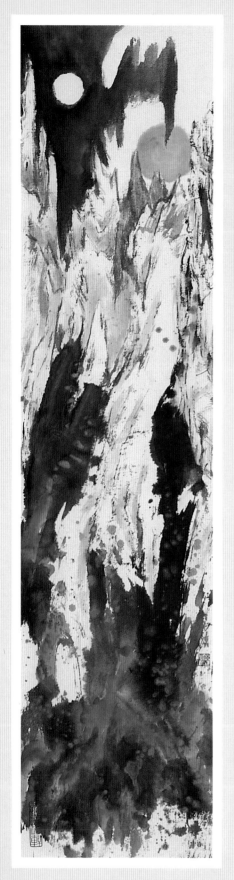

日落大地
sunset
lnd and color on paper.

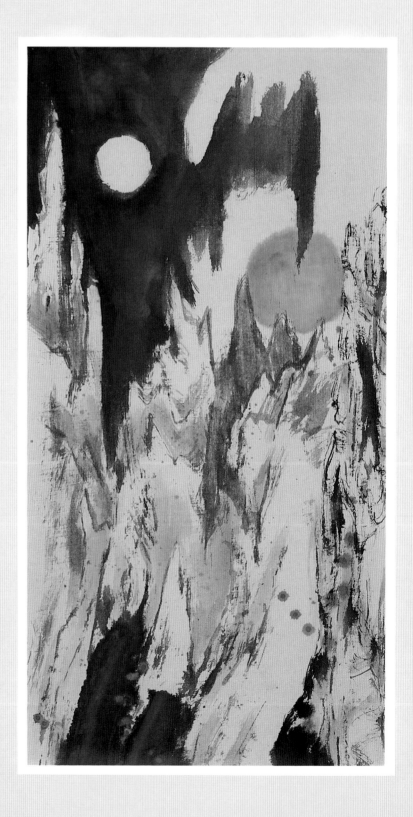

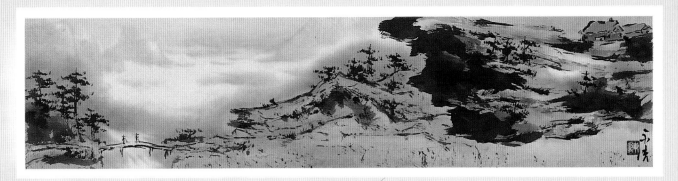

白雲故鄉

My Native Land Under White Clonds

Ind and color on paper.

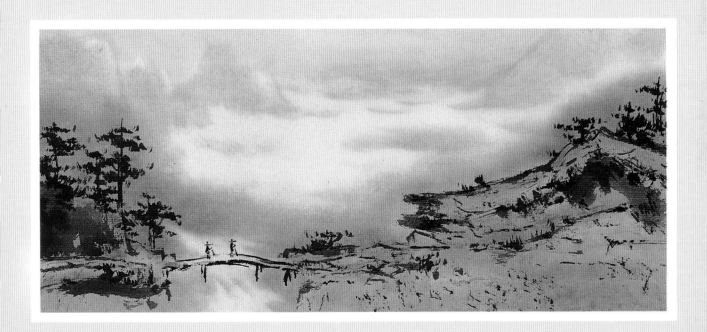

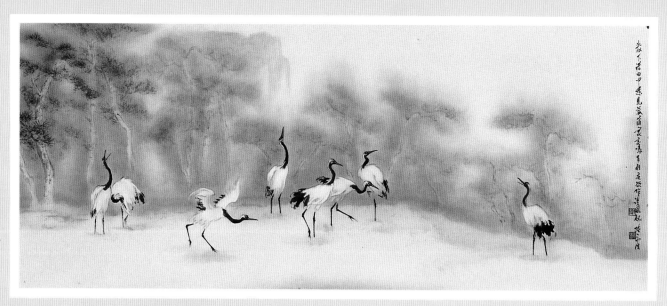

鶴舞
Cranes
Ind and color on paper.

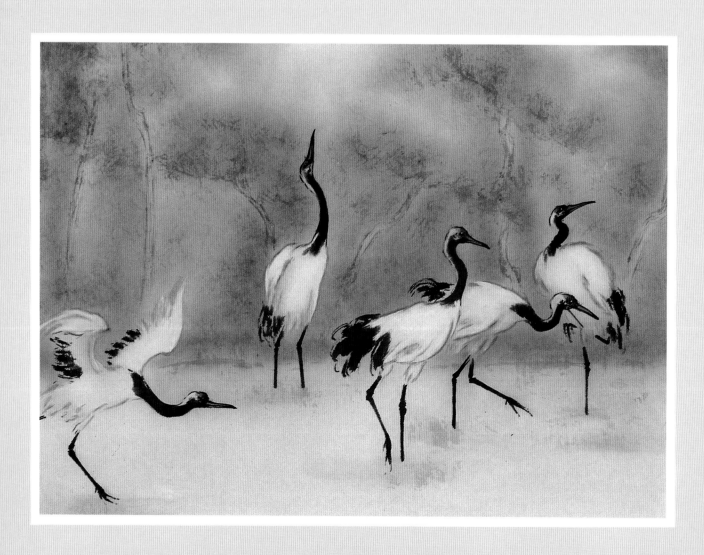

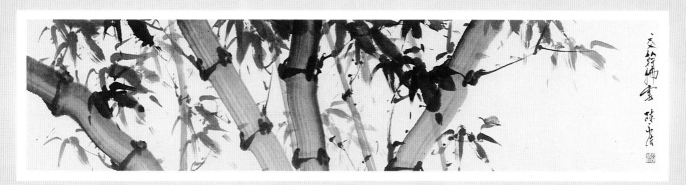

竹
Bamboo
Ind and color on paper.

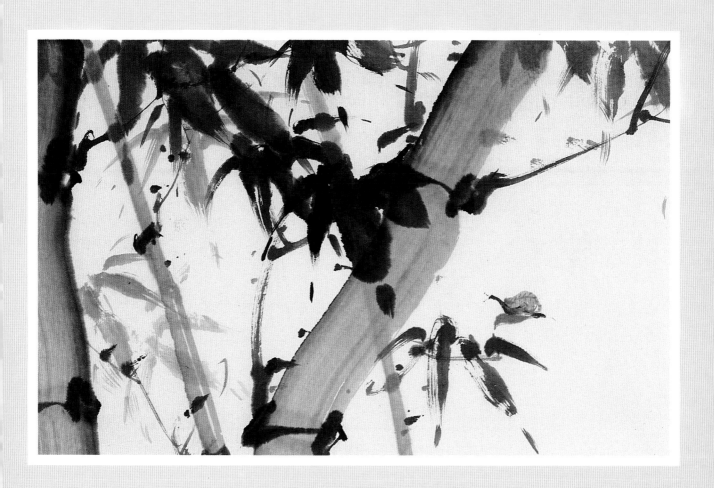

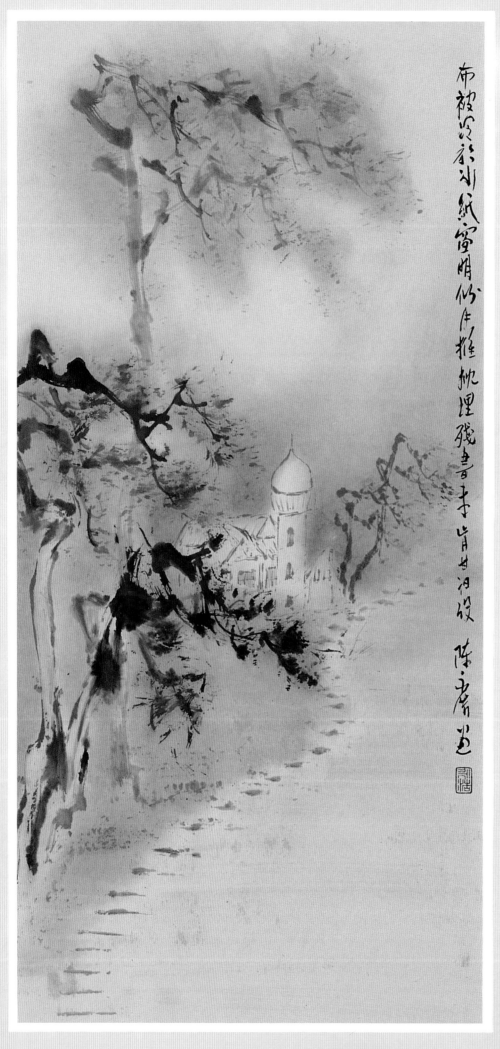

園林
conntryside
lnd and color on paper.

122

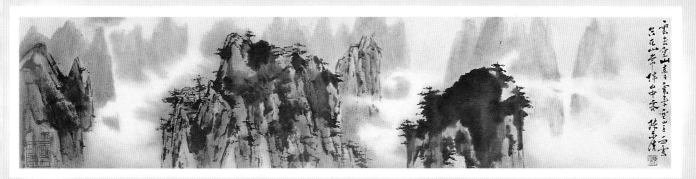

雲山縹渺
The Munntains and clonds in a dim View
Ind and color on paper.

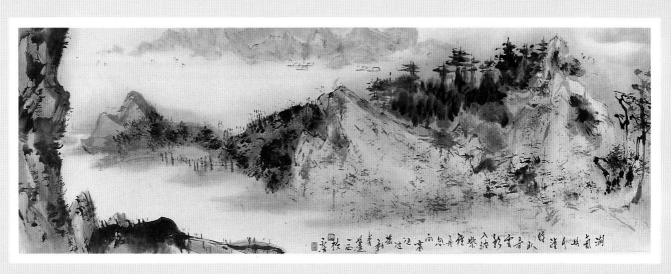

歸舟
R eturning boat
Ind and color on paper.

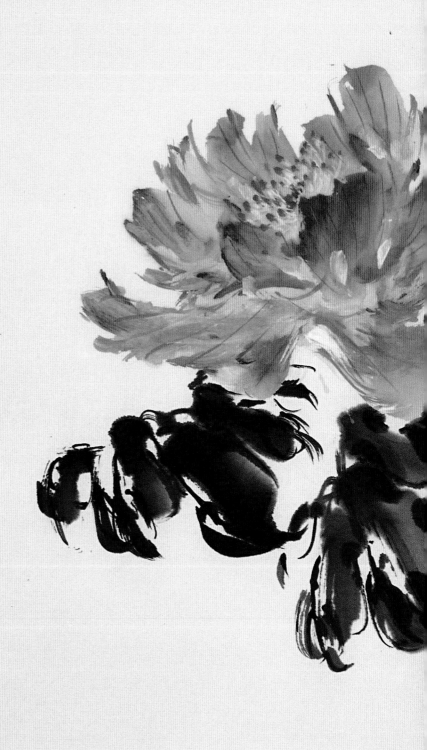

三月洛陽花似錦
春風得意冠群芳

陳少清

春深霸衆香

spring splendor

Ink and color on paper.

124

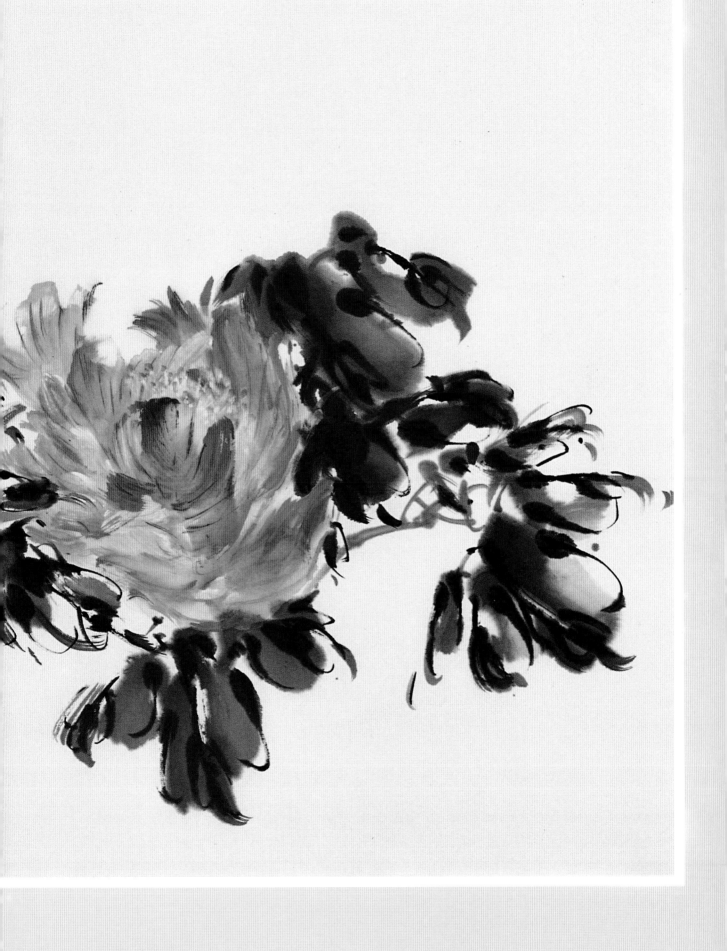

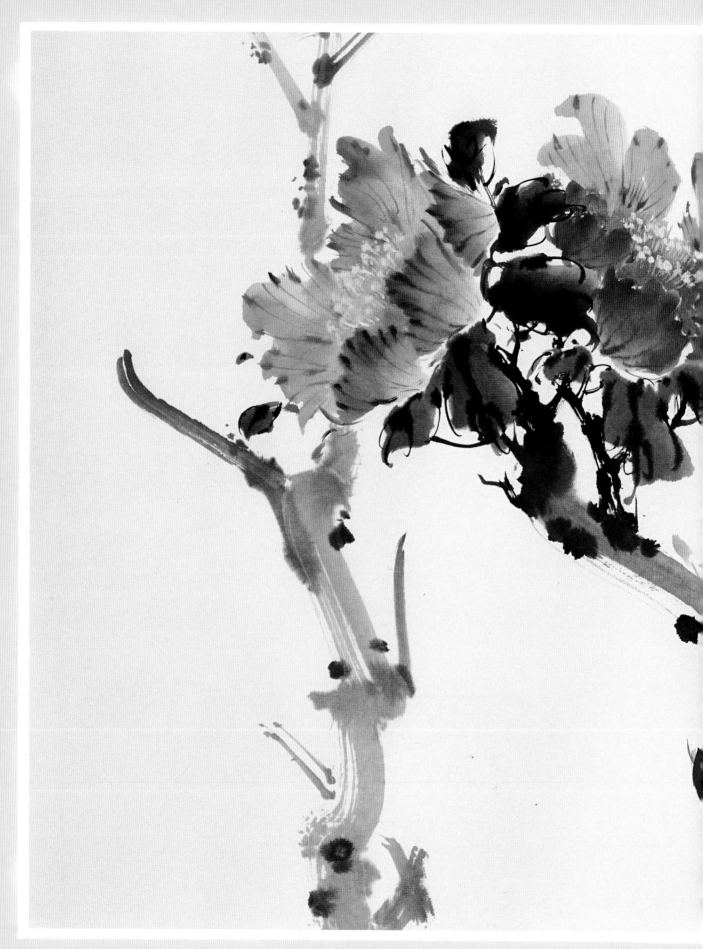

歲寒不受雪霜侵
Bird and Tea Blossons
Ink and color on paper.

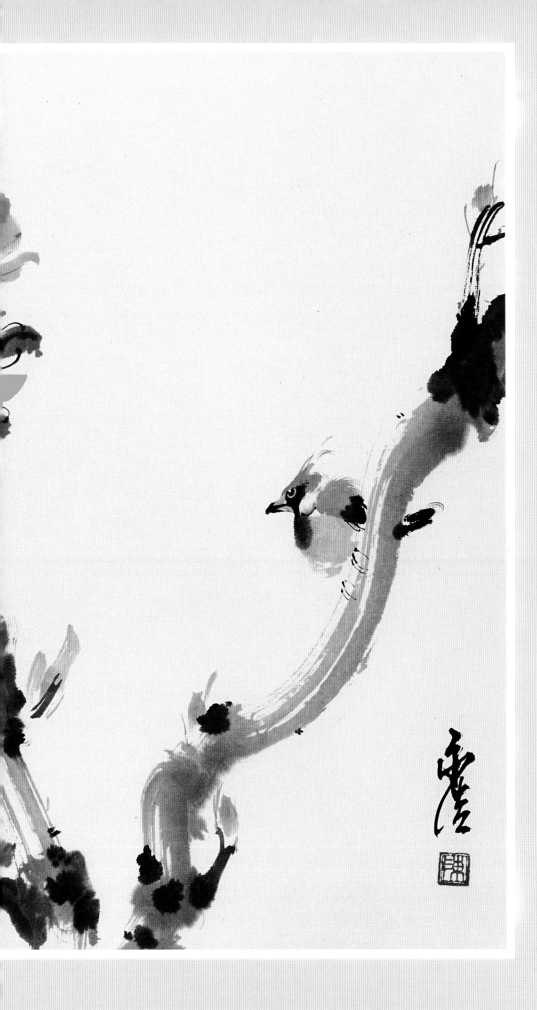

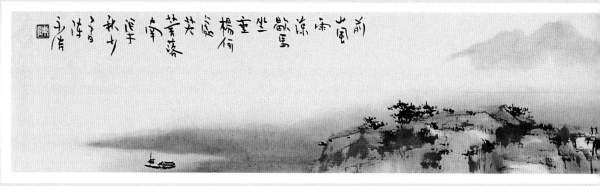

雲山暮靄
Landscape at Evening
Ind and color on paper.

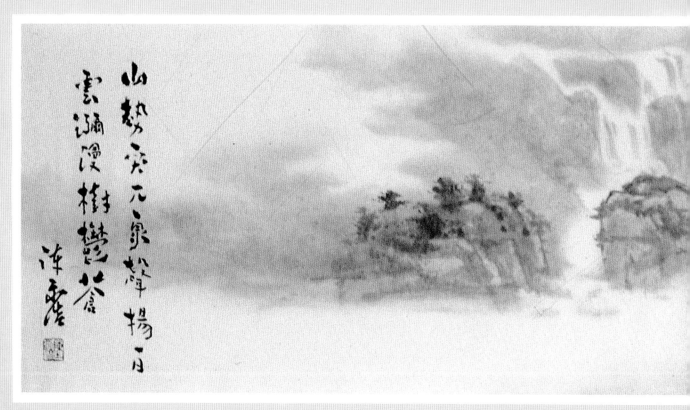

幽泉
Waterfall
Ink and color on paper.

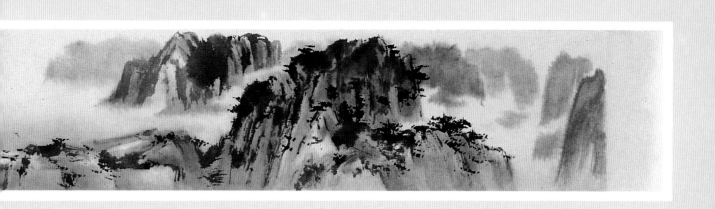

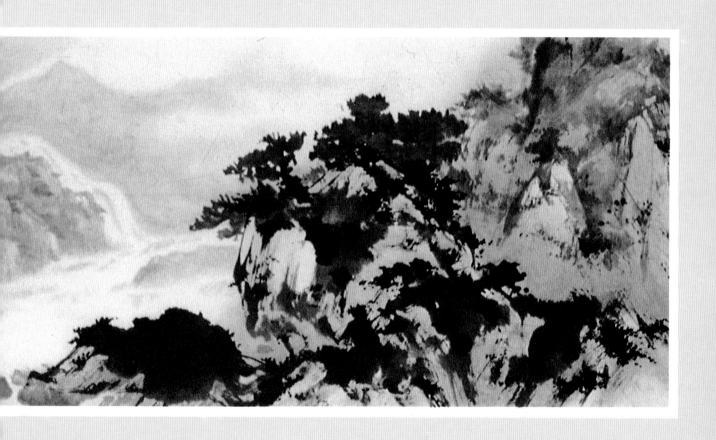

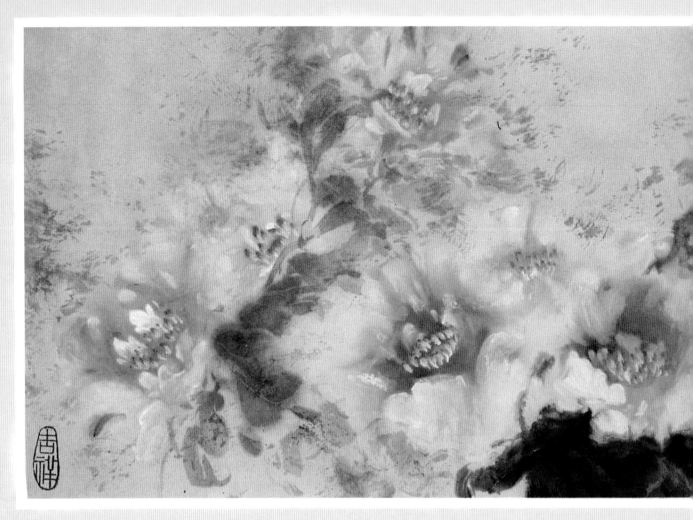

春容
Spring Glow
Ink and color on paper.

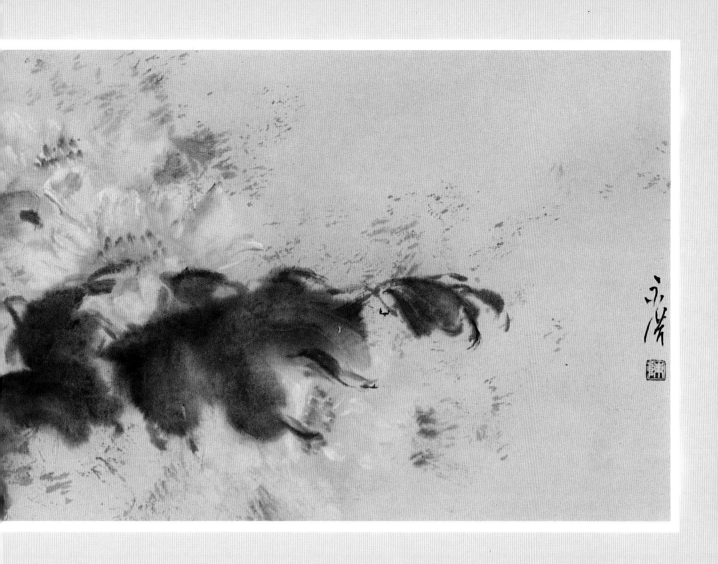

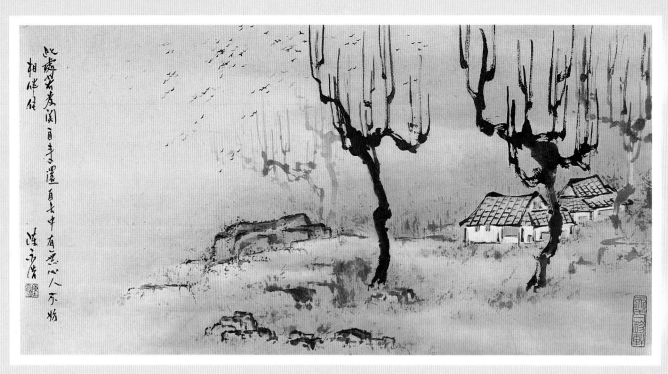

晩霞撒錦

Evening clonds Look Like Brocade

Ink and color on paper.

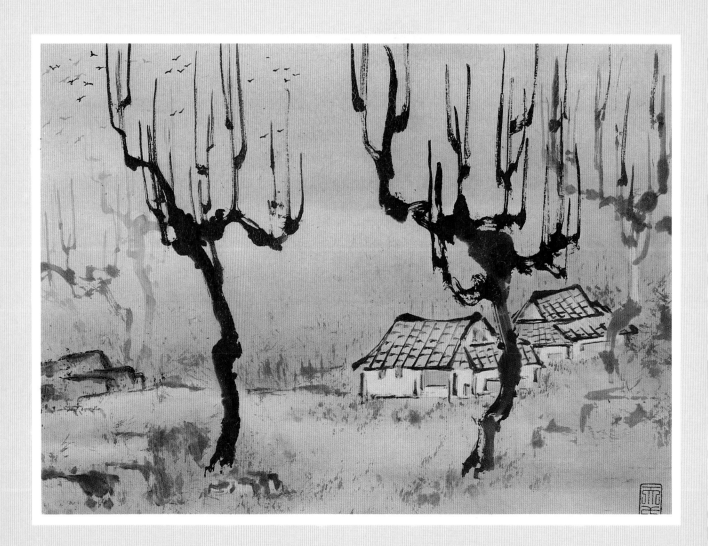

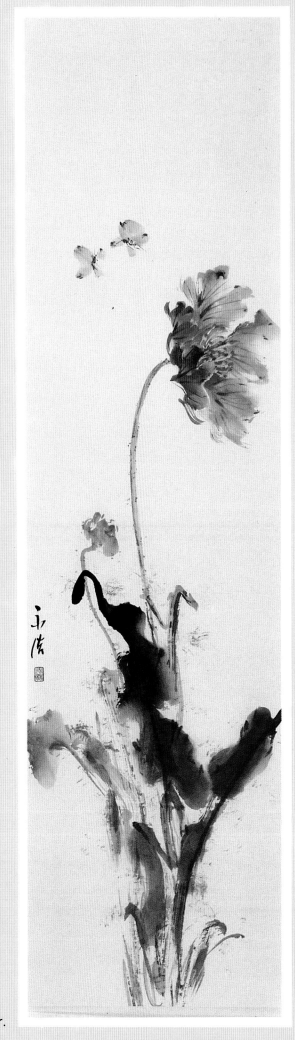

花香蝶己知
Peony and butterfly
Ink and color on paper.

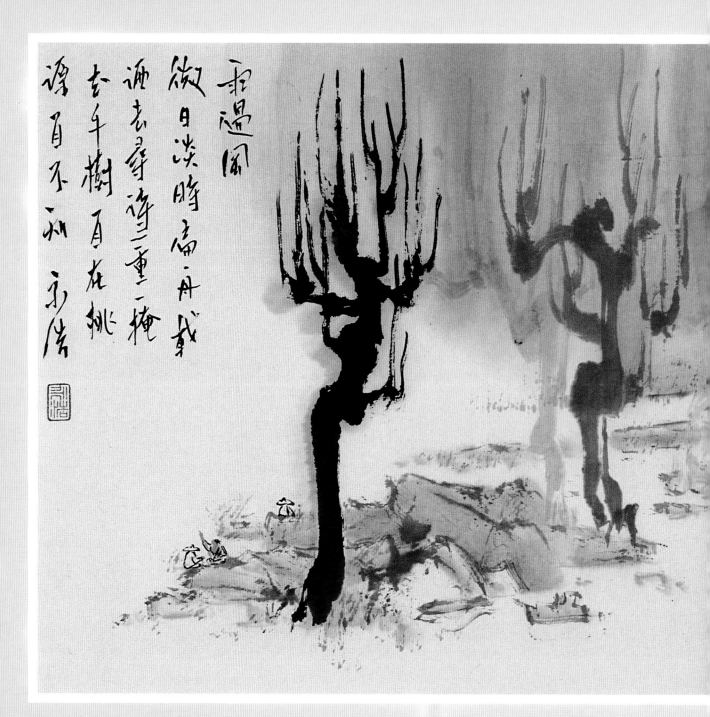

春林對坐
Sitting Under The spring Tree
Ink and color on paper.

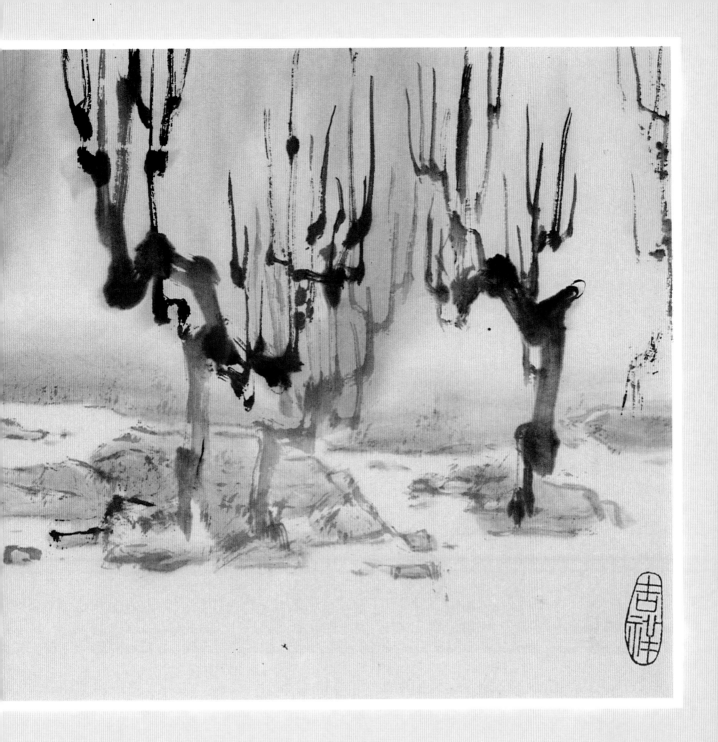

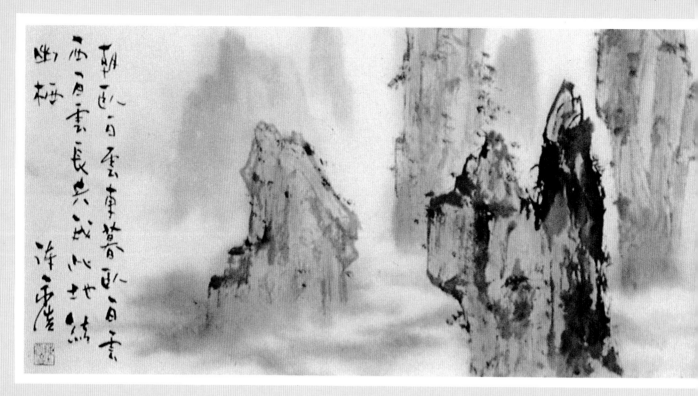

白雲出岫
Mountains and white Clouds
Ink and color on paper.

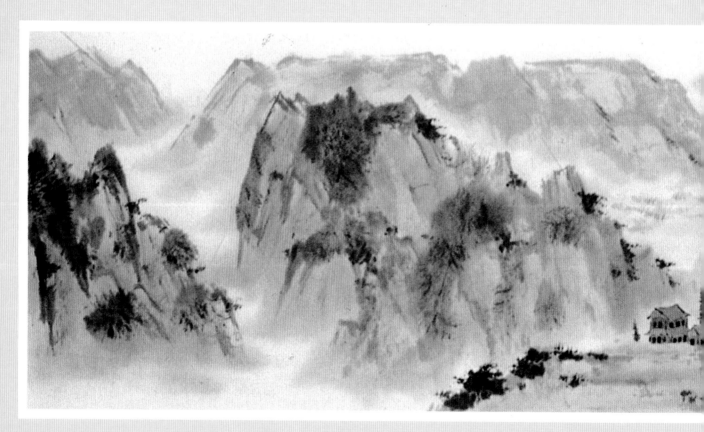

湖畔春晴
Ladeside Scene in spring
Ink and color on paper.

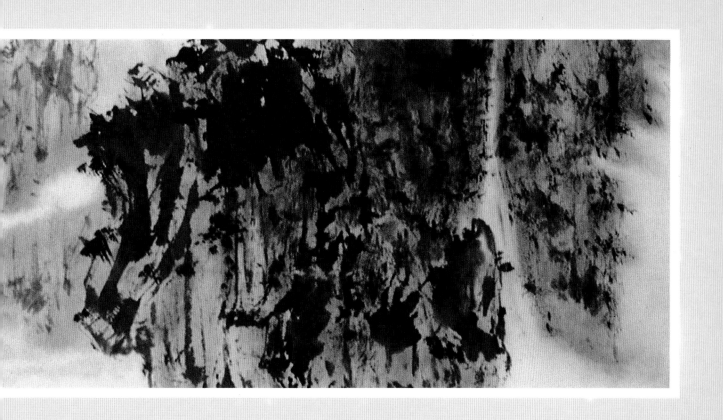

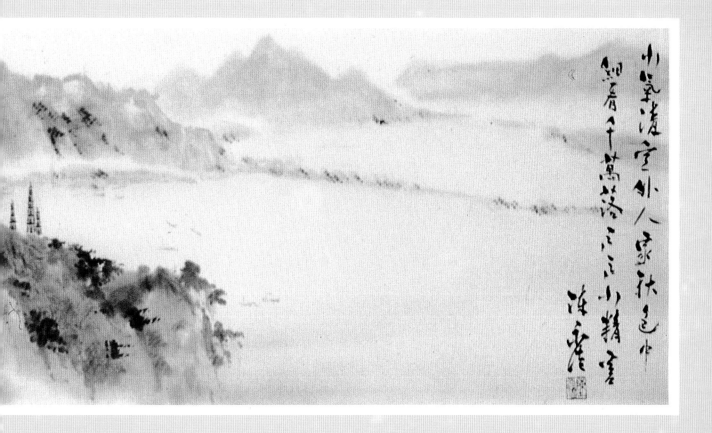

小艇清空外人家秋色中
鷗眉千萬落三三小精盦
陳遵

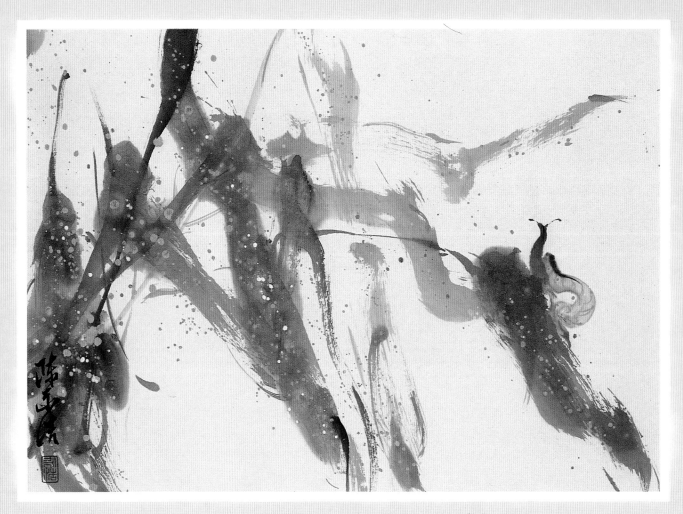

寧靜

silence

Ind and color on paper.

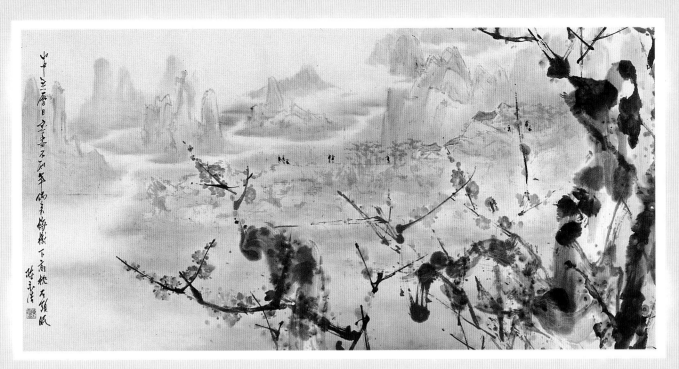

仙源何處尋
Where the Fairyland Conld Be Fonnd
Ind and color on paper.

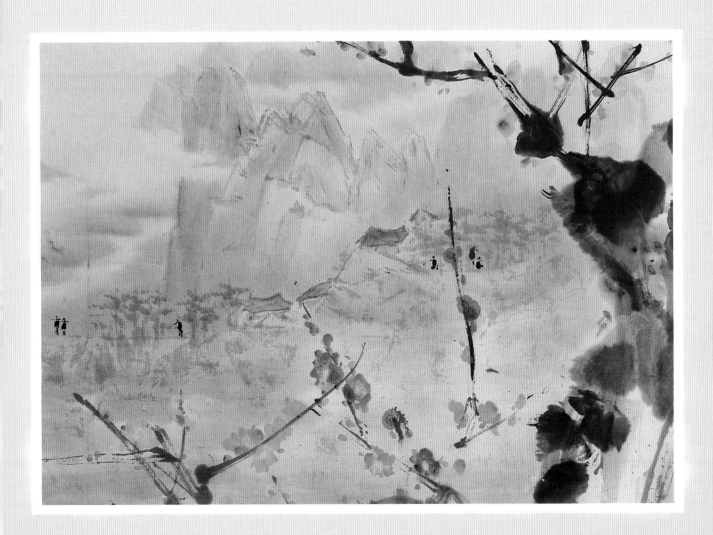

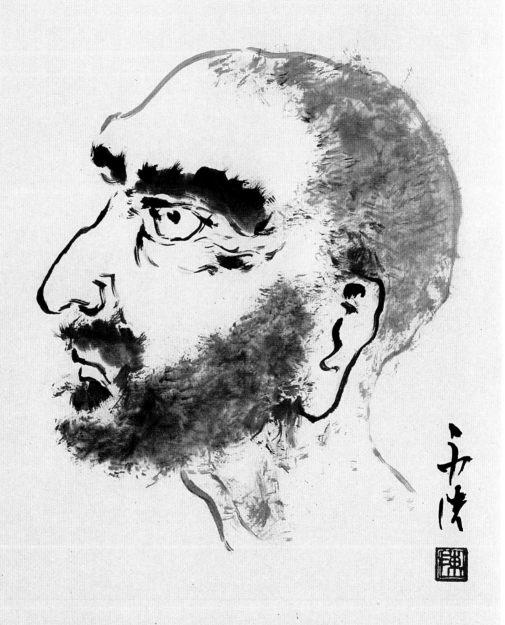

先知
Fortune－Teller
Ink and color on paper.

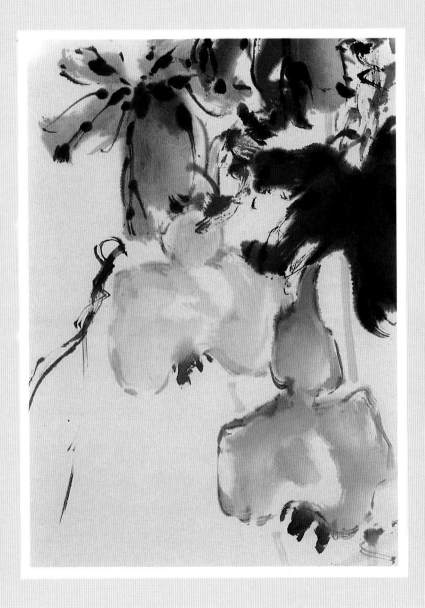

秋瓜
Pumpkin
Ink and color on paper.

141

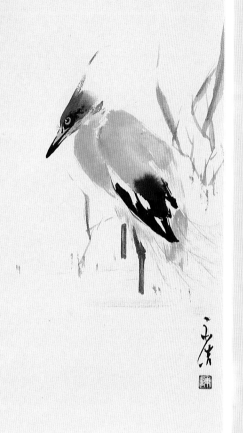

獨立
Morning Watch
Ink and color on paper.

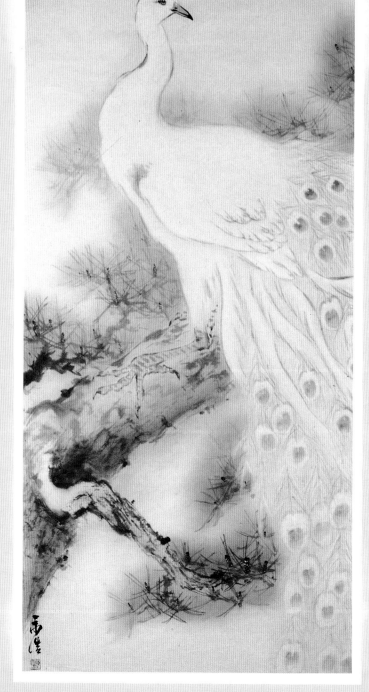

孔雀
Peacock
Ink and color on paper.

142

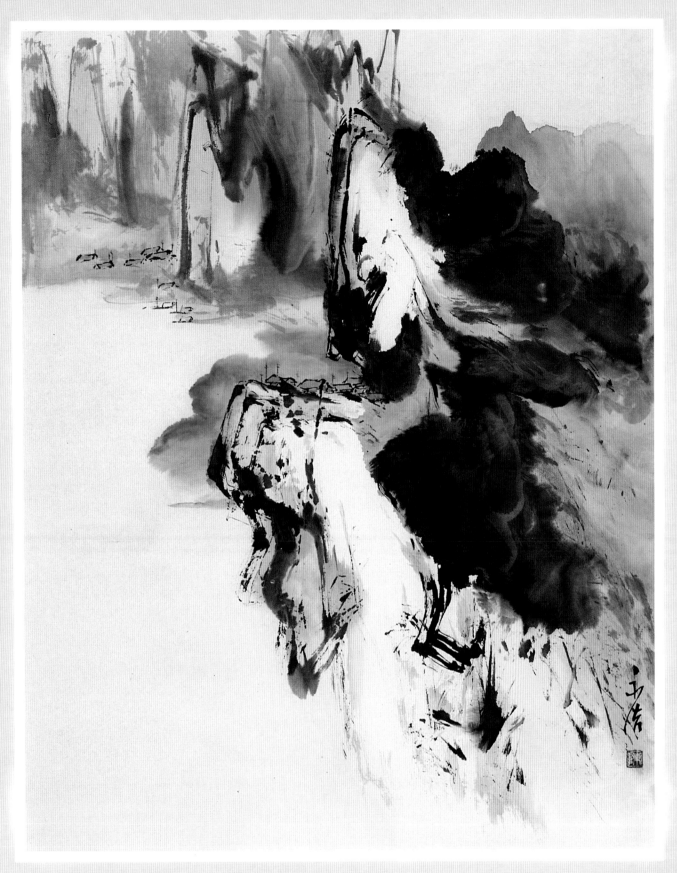

坡
slope
Ind and color on paper.

陳永浩彩墨畫集

定價：650元

出 版 者：新形象出版事業有限公司
負 責 人：陳偉賢
地　　址：台北縣永和市中正路391巷2號8樓
電　　話：9207133・9278446
ＦＡＸ：9290713

編 著 者：陳永浩
翻 譯 者：Christopher M. Nelson
發 行 人：顏義勇
總 策 劃：陳偉昭
美術設計：張呂森、葉辰智、蕭秀慧
美術企劃：林東海、張麗琦

總 代 理：北星圖書事業股份有限公司
地　　址：台北縣永和市中正路391巷2號8樓
門　　市：北星圖書事業股份有限公司
　　　　　永和市中正路498號
電　　話：9229000(代表)
ＦＡＸ：9229041
郵　　撥：0544500-7北星圖書帳戶
印 刷 所：皇甫彩藝印刷股份有限公司

行政院新聞局出版事業登記證／局版台業字第3928號
經濟部公司執／76建三辛字第214743號

中華民國83年7月　　第一版第一刷
ISBN 957-8548-61-3

畫室：

中壢市中北路二段119號3Ｆ
ＴＥＬ：(03)457-5245

花蓮市中山路699號
ＴＥＬ：(038)573-688

台北市館前路中國青年服務社
任教

國立中央圖書館出版品預行編目資料

陳永浩彩墨畫集：Ink and colour paintings
of Chen Yung Hao／陳永浩編著.——第一版
.——臺北縣永和市：新形象，民83
　　面；
ISBN 957-8548-61-3(精裝)

1.繪畫—中國—作品集

945.6　　　　　　　　　　　　83006136